BOWMAN LIBRARY
MENLO COLLEGE

P9-CKD-911

Undergraduate

book fund

contributed by
friends of Stanford

STANFORD UNIVERSITY LIBRARIES

WITHDRAWN

Modern Artists

Segal

Harry N. Abrams, Inc., Publishers, New York

William C. Seitz

Segal

Series Editor: Werner Spies

Standard Book Number: 8109-4420-0
Library of Congress Catalogue Card Number: 72-3255

All rights reserved. No part of the contents of this book may be reproduced
without the written permission of the publishers, Harry N. Abrams, Inc., New York
Copyright 1972 in Germany by Verlag Gerd Hatje, Stuttgart
Printed and bound in West Germany

During the last decade George Segal, a painter until 1958, has achieved international recognition as a sculptor, breathing new life into the debilitated tradition of realistic figure sculpture. Such an accomplishment would have been less noteworthy, especially in the Mod sixties, if it had been realized by an obdurate antimodernist; but Segal, whose view of art is as embracing as that of many modernists is exclusive and parochial, entered the New York scene as a sculptor in intimate contact—as sponsor, collaborator, and participant—with the most dispersive tendencies of the early sixties. In 1958 his chicken farm in South Brunswick, New Jersey (from which he had earlier wrung a hard-earned living) was the setting for the initial outdoor Happening by his friend Allan Kaprow. The string of interconnecting coops, transformed into a suite of workshops, became a rural base for the artists of the cooperative Hansa Gallery in New York, directed by Richard Bellamy and Ivan Karp, and an unofficial annex of the radical art department of Douglas College, Rutgers University, where under the direction of the painter and printmaker Reginald Neal, Segal, Kaprow, Roy Lichtenstein, George Brecht, Robert Watts, Robert Whitman, Lucas Samaras, and other young innovators were teachers or students. Following the completion of a bachelor's degree in art education at New York University in 1950, Segal "farmed, taught art, built houses and chicken coops, painted pictures, made sculpture, and exhibited at the Hansa Gallery." (In 1963 he received a master of fine arts degree from Rutgers, and in 1970 an honorary doctorate.)

Even before he originated a new method of figure sculpture Segal recognized, as he recalled in 1967, that the sensibility of the sixties was "characterized by a unique openness of attitude, a willingness to use unfamiliar materials, forms, and unorthodox stances in the work produced, an unwillingness to accept standard value judgments, a tendency to probe, act, live, and work with final judgment suspended, an appreciation of the mystery, unknowability, ambiguity of the simplest things."[1] The Hansa group introduced Segal to most of the major directions then animating the New York scene, and after their Gallery closed in 1959 the same associations continued at the even more venturesome Green Gallery, also directed by Bellamy. Concurrently, Segal was a sympathetic observer of the environments and Happenings of Red Grooms, Robert Whitman, Claes Oldenburg, and Jim Dine taking place at the Reuben Gallery and in lofts, stores, and more unexpected places in or near New York. He was an active collaborator and participant in some of those organized by Kaprow.[2] Collage, assemblage, "junk culture," environments, and Happenings, indeed, were instrumental for the innovation of Segal's situational mode of sculpture.

Like Kaprow, who had studied with the key figures Meyer Schapiro, Hans Hofmann, and John Cage, Segal belonged to a generation in whom the characteristic subversiveness of the modernist was reinforced by the historical and stylistic

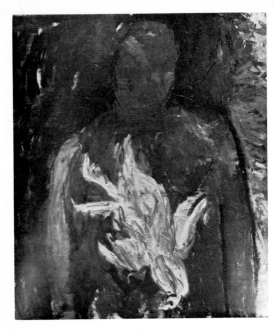

Self-Portrait with Dead Chicken, 1957

sophistication of the advanced art-history student. A genial, permissive, yet entirely serious collaborator, Segal was open to almost any novelty or extravagance of art, or anti-art, activity; yet his own sculpture, conceived at the center of this refractory circle, was a self-contained and quite separate phenomenon.

Like other artists who germinated in the wake of Pollock and De Kooning, Segal began with, but then rejected, the painterly improvisation and self-projection of Abstract Expressionism. Rooted in his personality rather than in prevailing influences, however, was his stubborn involvement with the human situation—a predisposition documented, in 1957, by a frontally posed painting of a male figure stigmatized by a dead chicken (left). The treatment is expressionistic and the subject is autobiographical. Evident also in the paintings at the end of the fifties is a second inclination, toward a taut picture plane and two-dimensional distribution of areas, that contradicts the bulkiness of the lifesize figures. A plaster bas-relief of 1958 (page 7) synthesizes these qualities. In its erotic exaggerations the recumbent odalisque plainly recalls Matisse's bronze *Reclining Nude* and painted *Blue Nude* of the Fauve period.[3] Over lifesize, the figure swells forward from the wooden wall rather than upward from an illusionary ground plane, and runs of plaster drip from the body down the vertical surface, like paint from the limbs of a De Kooning Woman.

In a transitional exhibition at the Hansa the next year Segal showed, along with paintings, his first rough essays at sculpture: three lifesize figures fabricated from wire, plaster, and burlap: one standing, one lying, and one sitting on a rickety but actual chair (page 7). "They looked to me," Segal recalls, "as if they had stepped out of my paintings."[4]

An artist's future can be determined by one crucial discovery: for Monet it was the first day he painted in the open air with Boudin; for Mark Tobey it was the fusion of Cubism with calligraphy; for Frank Stella it was painting with black stripes. Whether physical, perceptual, stylistic, or technical, such revelations reconcile segments of his sensibility previously disjoined or at cross-purposes, to concentrate their combined energy, as a magnifying glass does rays of the sun, on a point. In 1960 Segal was wrestling with a dilemma of options, each seemingly a total vision demanding "unwavering fealty to a rigid set of principles."[5] He felt pressed to choose between Cubism and Surrealism, fantasy and actuality, introversion and the environment, organic and geometric form, figuration and abstraction. For Segal the crucial event occurred in that year. A student made him a gift of some plaster-impregnated bandages, a newly developed product used to make casts for broken limbs:

> Immediately I knew what to do. I was my own first model. I posed nude in a chair outside, and my wife wrapped me in the plaster-impregnated bandages from neck to toe. I knew nothing about how plaster sticks to hair, and suffered unexpected agonies as well as equally unexpected pleasurable reactions to the

warmth of the drying plaster. As it dried everything shrank, so it was like being encased in a solid Band-Aid. I had to pull the plaster shell off with great pain. It broke into pieces, which I then laboriously reassembled. That became *The Man at the Table* [page 28]. I had found my medium.⁶

This labored but prime work shows the marks of struggle, but by 1962 Segal was using his new method with skill and authority.

That the first sitter was the artist himself, and that his wife was (as she is still) his assistant, is pertinent; for Segal's is an intimate art. His subjects are seldom professional models, but members of his family, artists and other friends, neighbors, volunteers eager to participate, and occasionally patrons who commission portraits. The settings and situations also reflect his life, and are often drawn from the megalopolitan sprawl that lies between lower New York and New Brunswick: the urban slums, the blighted, polluted countryside, and the industrial and commercial jungle along the New Jersey Turnpike. No single term can describe this eerie wasteland. Its sights, odors, sounds, sensations—each one an affront to a conservationist's sensibility—combine the fearsome grandeur of the skeletal, flaming petroleum refineries, other large industrial structures, their noxious effluvium, the gases, snarls, and concrete vistas of the Turnpike, soot-covered clusters of substandard homes, gas stations, automobile graveyards, junk heaps, blighted fields, and even a few dilapidated farms. Neither urban nor suburban, the Dantesque spectacle is monstrous; yet, in its uncontrolled, voracious appropriation and spoliation of nature, it is moving—even (as artists invariably recognize) beautiful (page 8). The people that sit for Segal are, most often, those who inhabit the city or this blighted countryside:

> I usually make sculptures of people I know very well in situations that I've known them in. And if that involves a luncheonette counter, places in the house or other places where I go: gas stations, bus stations, streets, farm buildings—this must all do with my experience. I live in this environment.... It is a huge heap of art material for me.... I remember my life with the objects and I also look at these objects "plastically" (I suppose that is the term), "esthetically," for what these shapes are. And how people relate to these shapes and how they don't relate in a human way, intrigues me.... As long as there has been a very alive emotional experience between me and the person, or between me and the object, or both, only then do I incorporate it into my own work.⁷

Anyone who sits for Segal must be willing to share interactive, self-revealing, and sometimes painful experiences. The sitter must hold characteristic, and often difficult, positions, accept tactile as well as visual contact with the artist, endure the discomforts of being covered with petroleum jelly and wrapped, part by part, in wet, plaster-soaked bandages and Saranwrap, sensations of constriction, heat, and cold as the coating sets, and, finally, the dismemberment and removal of the plaster

Reclining Woman, 1958

Seated Figure, Lifesize, 1958

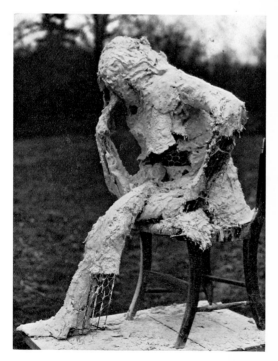

7

Route No. 1 Landscape

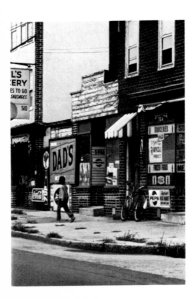

Scene Along Route No. 1

carapace section by section. The longer second stage—assemblage of the body-parts into a complete figure—is represented in *Self-Portrait: Artist, Head, and Body* (1968; page 66). For Segal this is the most demanding part of the process: "Originally, I thought casting would be fast and direct, like photography, but I found that I had to rework every square inch. I add or subtract a detail, create a flow or break up an area by working with creases and angles. I'm shaping forms."[8]

Within the limitations imposed by theme, sitter, pose, and setting, the possible choices between variations in position, shape, surface, and degree of detail are myriad. A hand, for example, is capable of an infinity of inflections. Thus Segal's process at this stage is that of creative synthesis rather than replication. The inner surface of the shell—the negative cast that retains an exact, detailed impression of skin and clothing, and sometimes the clothing itself—remains encased *within* the finished work. Final articulation of the outer, visible form and surface is determined entirely by his judgment, hand, and thematic intent. It neither counterfeits flesh nor loses the marks of materials and processes:

> Is there any reason for the unrefined surfaces? Yes, there is. It would be just as simple to take a human hand, put plaster on it, let it dry and take it off. What's inside would be a perfect negative. You'd get all the skin pores, the wrinkles, the incredibly minute detail. I choose to use the exterior because in a sense it's my own version of drawing and painting. I have to define what I want, and I can blur what I don't want. I can dissolve something in a puddle if I like. It bears the mark of my hand; but it bears not the work of my hand so much as the mark of my decisions in emphasis. I'm not really interested in naturalistic reproduction. If I were, I would have to use a completely different process.[9]

Segal's move, in 1961, to a new medium and an original, and what was seen as a mimetic, method was made, as he has said, under the pressure of "wildly dissimilar" values, ideas, and art forms. It "had to do with the painful necessity of starting from the beginning, to find a way of making things that agreed with the way I was experiencing things. Blessed or cursed, I was responding to all the polarities, and had to find a way to connect real space, direct sensation, with [a] metaphysical dream state. Specific and general had to become entangled; figure and abstraction had to fuse."[10]

The Bus Driver (page 30; now in The Museum of Modern Art, New York) and *The Dinner Table* (page 25; a group portrait modeled by Segal and his wife, the Kaprows, the artist Lucas Samaras, and the writer Jill Johnson) were included in the *New Realists* exhibition held in 1962 in a temporary annex of the Sidney Janis Gallery—an empty store on West 57th Street. The title of the exhibition was borrowed from the French critic Pierre Restany, for whom it was a catchall for any unconventional artist or manifestation that caught his fancy. The diversity of the works shown reflected the inchoate, market-conscious flag raising of the

8

period. Segal's pieces dealt with ordinary contemporary subjects, and juxtaposed starkly white plaster figures with furniture, dishes, automotive equipment, and other actual objects. It is therefore not difficult to see why his reputation rose rapidly on the crest of the wave that was shortly to be labeled "Pop Art."

Like Pop, Segal's art employed common themes and objects, but he approached them differently from Warhol, Wesselman, Marisol, Lichtenstein, or Rosenquist. Pop artists found their material not in actual situations, but in the synthetic imagery of photographs, newsprint, comic strips, billboards, highway markers, and television—from The Media. The archetypical Pop artist was a cool, detached, and ironic commentator on the current (or campily *passé*) scene. In some instances naively, and in others by intent, Pop's exposure of the ominously meretricious settings and the flagrantly profit-motivated enterprises that dominate contemporary life was devastating.[11] But Segal's environmental sculpture, extracted directly from the existential realities of everyday work, play, relaxation, gratification, and repose, has little connection with the media-generated stance of Pop. Indeed, gamesmanship, the tongue-in-cheek, dandyism, camp—the "cool" view of art and life—are simply inimical to his nature. His serious, thoughtful Americans, totally absorbed in work, in the daily routines of dressing and attending to their bodies, worrying, sleeping, loving, or daydreaming, bespeak a wholly different order of meanings from those of Pop. Apparent in every scrap of his painting, drawing, and sculpture, Segal's undisguised concentration on the human condition is surprisingly, almost awkwardly, earnest seen against the high-keyed backdrop of the early sixties.

Until the post-Pop school of radical realism, Segal (whose casting method began that trend in sculpture) was the most explicit of contemporary figure sculptors; yet he is at the same time, perhaps, the most universal. His method, by which size, proportions, and general disposition of the figure are determined by the bodily peculiarities of a specific person, obviates ancient and fundamental sculptors' problems, among them overall size, figure canon, and the entire repertory of expressive, decorative, and perceptual deformation. By paying a heavy initial debt to nature, Segal liberated his art from the dilemma of stylistic influences. Unlike Lehmbruck, Lachaise, Giacometti, and other modern figure sculptors, for whom deviation from median bodily proportions was a primary expressive means, Segal welcomed the constraint of actual forms and relationships. Similarly, he accepted as themes the mundane activities of ordinary persons.

Since the seventeenth century, radical realism has been one of the alternatives open to sculptors. The nineteenth-century Japanese Hananuma Masakichi achieved what the "believe-it-or-not" impresario Robert L. Ripley ballyhooed as "the most lifelike image ever made by man" in a nude, lifesize self-portrait to which he affixed his own hair, teeth, toenails, and fingernails. Since 1968 the sculptors

Duane Hansen and John de Andrea have achieved an extreme verism far beyond that of Tussaud's, through imitative color, facial and bodily details, simulated hair, and actual costumes and accouterments. In his procedure, surely as close as these sculptors to physical fact, Segal invariably softens or fills linear minutiae, eschews natural color for the whiteness of plaster, and eliminates distracting secondary anatomical forms. (Giacomo Manzù achieved a comparable degree of realism in his *Young Girl on a Chair* [1955], in which an actual piece of furniture seems to have been incorporated and cast in bronze.) Segal's figures are almost always portraits, but small facial peculiarities are sacrificed, as in a soft-focus photograph or the wax heads of Medardo Rosso. It is a portraiture more of demeanor than delineation, however, and its connotations are somehow generic and universal.

In the first major article on Segal, Allan Kaprow described his figures as "vital mummies."[12] Deprecatory though this characterization now sounds, it calls attention to the similarity of Segal's method to Egyptian funerary enwrapment. Its effect on surface treatment and amplitude of form (although the plaster wall is seldom more than one-eighth inch in thickness), and the life-in-death, momentary-yet-timeless aura, elevate Segal's environments above snapshot immediacy. Another parallel, also from antiquity, has repeatedly been drawn: the haunting resemblance of certain of his figures to the now nonexistent bodies of Romans who died during the eruption of Vesuvius in A.D. 79. The once miry and liquid lava hardened to form stony crusts around the corpses—natural molds from which rough-surfaced casts were made of the fallen bodies. They melt into the ground at the moment of death just as Segal's sleepers and lovers melt into their beds, to effect a comparable transmutation of the particular into the universal.[13]

Unlike Maillol, Gerhard Marcks, Paul Manship, and other classicistic figure sculptors, for whom the body was primarily a means toward purity of formal relationships, Segal employs not only the body, but also clothing, attributes, and environmental objects to define the locus of a consciousness and a situation. At each phase in the realization of a project, beginning with the choice of theme and protagonists, and especially throughout the necessarily intimate contact with their bodies, clothing, and appurtenances, Segal's art partakes of *Einfühlung:* "feeling one's way into" or *empathy*, a special kind of experience that (as the philosopher and psychologist Theodor Lipps, who put forward this attitude as an attribute of art, explained in nuanced detail) combines perception, identification, and self-arousal. According to Lipps, any participating spectator of an art work activates what he calls a "self-feeling."[14] How much more crucial this quality of experience becomes for the artist in a process that, as the following comments by Segal emphasize, places him, like a psychiatrist or therapist, in direct communion with each sitter, psychologically as well as physically:

I conceive the situation. Then I have to be very careful and ask the right person,

for several reasons. A person's inner set of attitudes comes out in the plaster somehow. Why, I don't know, but it simply happens to be true. So they have to be capable of sensing what the situation is. Often it's enough for me simply to describe the situation. But the best pieces come where a minimum of talk is required. So I am dependent on the sensitivity and response of the people posing for me.[15]

One would be tempted to dub Segal a "humanist," had not this mutilated vocable been commandeered by those for whom the representation of human bodies—preferably deformed, emaciated, or bloated—is more a denial than an affirmation of human virtues. Because of his natural, affectionate immersion in the full range of experience, Segal has re-created live situations without either sensationalism or moralism, usually avoiding overtly melancholic, calamitous, and extremist themes. Even *Execution* (page 67) and *The Bowery* (page 77) mitigate the harsh verism of Duane Hansen's treatment of such violent subjects.

In the amount of space they occupy, and the number of figures, objects, and architectural elements they include, Segal's works range from fragments of the body to environments so inclusive that they dominate the personages within them. Between are the single figures, which make up an important and all but independent *oeuvre*. The poses (if such they can be called) are often focused and explained by the inclusion of a comb, an article of clothing, a cane, a professional tool, or some other functional object; or the figure's living-space is expanded by the addition of an appropriate chair, table, or bed, a bicycle, a section of an automobile or bus, a dentist's drill, or (for a sign painter or construction worker) a scaffolding. Scale and emphasis change as the environment becomes larger and more ambitious, but even in a single figure, Segal is concerned with the ambiance its presence demands, as well as with the smallest fragment of a gesture: "the turn of two fingers." Important among this group are the numerous, superbly realized female figures. Like the women in the oils, pastels, and wax sculpture of Degas, they often perform the most intimate ablutions. As did Degas, Segal delights in the characteristic gestures of ordinary tasks. Degas also avoided prettification, and he even gave certain of his sculptured figures environmental emphasis by incorporating real elements—a muslin *tutu* and silk hair-ribbon—in his famous *Petite Danseuse de Quatorze Ans*, and, for two of the Bathers, a metal basin and a pot to simulate bathing tubs.[16] Yet few artists have been colder, or showed less empathy toward their sitters, than Degas, who viewed laundresses and girls of the *corps de ballet* as he did horses. Segal's identification with his subjects, moreover, bears no trace of the sociological intent of Courbet's *Stonebreakers* or *Young Women on the Banks of the Seine*. It is akin to Toulouse-Lautrec's affectionate insider's studies of performers, eccentrics, and prostitutes; Bonnard's bathroom nudes of his wife, Marthe de Méligny; or Picasso's compassionate blue and rose periods. Yet Segal eschews

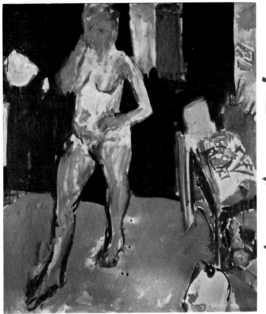

Model in Studio, 1957

Lautrec's extreme specificity, Bonnard's decorativeness, and, usually, Picasso's blue-period sentimentality.

Breaking with a centuries-long succession of brainless, empty-headed, carved and modeled female nudes, observed by their makers as aesthetic or sexual objects, Segal's figures always postulate *consciousness*. Thoughts and feelings, like the hidden individual physical records on the inner surfaces of the sculptural shells, have also somehow been trapped. It is striking to recognize how much more Segal's women are than effigies as they bathe, brush or arrange their hair, paint lashes or nails, remove or put on a shoe, a brassière, or some other article of clothing, listen to music, ponder, sleep, or simply exist in postures natural to them. Though they lack physiognomic detail, the faces are endowed with sensibility. Their attention usually seems to turn inward, concentrating on the needs of the moment; yet at some deeper level of consciousness they seem to ponder the ultimate confrontation that underlies everyday existence.

When Segal's first environments were shown, viewers were disquieted by the introduction of the starkly white plaster figures into settings of actual objects. A decade lessened this initial shock, making the situational meanings more accessible; yet the polarities of whiteness and environmental color, art and actuality, kinesthetic immediacy and immobility, are still Segal's hallmarks. Operative in the viewer's response to the white figures is a wide range of inherited associations. One may recall from childhood the "living statues" once featured in circus performances: a circular, tentlike canopy was raised with a fanfare of trumpets to reveal milk-white tableaux of male and female figures posing in skin-tight costumes. Carrying spears, lyres, and other neoclassical attributes, some were astride, or held the bridles of, powdered white horses. Except for the reflexive twitch of a muscle, the entire living composition held motionless as marble until the canopy was lowered. Against the gaudy color and cacophony of the big top, these tableaux offered to unsophisticated eyes a startling image of purity and beauty. The awe, pleasure, and even disquietude they inspired must in part have filtered down from the sculptural pretensions of "The White City" (The World's Columbian Exposition held in Chicago in 1893), the polished carvings of the "white marmorean flock" of American sculptors who worked in Rome at the beginning of the nineteenth century, as well as Thorvaldsen, Canova, and the long sequence of Greco-Roman revivals. Beyond such evident sources for our response to whiteness, as Robert Graves shows in *The White Goddess*, associations with whiteness (as with blackness) are far too numerous and involute to codify: purity, innocence, virtue, cold, death and ghosts, eternality, sickness, evil, and even feminine beauty. Edmund Spenser wrote of "two Swannes of goodly hewe," whiter than snow, and even than Jupiter, who, in the guise of a swan, was whiter than Leda, whom he courted: "So purely white they were,/That even the gentle streame, the which them bare,/Seem'd

foule to them...."[17] With a directly opposed connotation, Graves quotes Coleridge's *The Ancient Mariner* concerning the woman "dicing with Death in the phantom ship": "Her lips were red, her looks were free,/Her locks were yellow as gold,/Her skin was as white as leprosy,/The Night-mare Life-in-Death was she,/Who thicks man's blood with cold."[18] In introducing an exhibition of black-and-white works held in 1950, Robert Motherwell (an artist immensely sensitive to the associational potential of color) wrote of white as "snow's color," of "the black slit glasses used when skiing," and of "a chapter in *Moby Dick* that evokes white's qualities as no painter could, except in his medium."[19] Culturally conditioned responses to whiteness, in various contexts, expand in an endless network of diverse associations. Segal's figures in plaster—a medium usually regarded as temporary, or reserved for cheap decoration rather than serious or permanent art—give a new reverberation to this rich symbolism.[20] Contraposed by their introduction into such settings as a neon-lit dry-cleaning store, a movie lobby, a parking garage, a laundromat, or a bar, the uncolored effigies trigger an aesthetic and symbolistic shock. Needless to say, they should not—as one collector assumed who discarded the mattress, bed, and sheets he acquired as part of a work done in 1962, *Two Lovers on a Bed*, and replaced them with a white pedestal—be separated, either physically or in the mind of the spectator, from the objects that extend their aura and define the situation.

"With Segal," Marcel Duchamp wrote in 1965, "it's not a matter of the found object; it's the chosen object."[21] Segal is acutely aware that the objects he finds or builds, whether consciously or unconsciously chosen, are expressive if only because they are man-made; and, further, that those objects by which each person surrounds himself are projections, like his clothing or hairstyle, of his self-image. The angular rhythms of the figure in *Girl on a Chaise Lounge* (1968) are echoed by the tubular structure on which she sits, and the flimsy folding chair used for *Man in a Chair* (1968; page 74) seems about to bend beneath his massiveness and stolid stance, just as the drinking glass seems about to be crushed in the vise of his grip. The size, weight, bulk, and color of an object, or of an entire setting, project environmental values. Segal's most alienated figures are dominated by extended walls, doorways, or, as in *The Subway* (page 70) or *The Tunnel* (both 1968), by the oppressiveness of the urban setting. In the large environments, the thoughtfully calculated architectural enframement sets physical boundaries to a space that can be regarded from without, as one would a painting, or explored from within, for the size and space of the art work are one-to-one with that of the viewer. Segal explained his conception of environmentality in a comment on *The Gas Station* (pages 38–39) in 1964:

> Many people seem so shocked by seeing a realistic white plaster figure that they tend psychologically to focus only on the figures. What interests me is a series of shocks and encounters that a person can have moving through space around

13

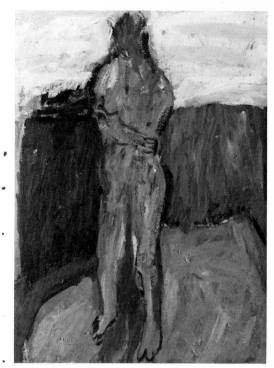

Standing Figure, 1957

several objects placed in careful relationship. I just finished working on a Gas Station piece. The man who posed really runs the Gas Station on the highway near my house. He's taking one step forward with an oil can in his hand. My private irony is if I took away the can and turned his fingers up he could be St. John the Baptist in coveralls. He's behind a huge glass window and you see him through glass and a pyramid of red oil cans. As you move around the glass you encounter him from the rear and see a black rack of seven black tires suspended several inches above his head. This sudden catching of fright doesn't happen until you move into the right position and then you know him differently. [22]

The prospect Segal sets for his art is broad: "the embracing of all content, contained in a new, open, three-dimensional form." It is therefore at the farthest remove from that, for example, of Stella, whose friend Carl André wrote, at the time the black-and-white paintings were first shown: "Frank Stella has found it necessary to paint stripes. There is nothing else in his painting." "My painting is based on the fact that only what can be seen there *is* there," Stella himself said later. [23] Partially because of his evident concern for content, Segal's formal achievement in an essentially new three-dimensional medium has received insufficient attention. Beginning with his paintings (pages 6, 12, and 13) and the wire-and-plaster sculpture that preceded the first wrapped figure, he was a realist and humanist during years of prejudice against both representation, on the part of the formalists, and serious commitment, on the part of the Pop circle. Minimal abstraction and the surrogate realism of Pop were dominant, and so-called formalist criticism was applied only to a narrowly circumscribed abstract vocabulary. Segal has always been concerned—even obsessed—with formal purity, but for him it is a core, uncovered during the often messy process of working out an idea or, symbolically, by clearing away the surface sludge of ordinary life. Formal development must therefore parallel the distillation of a theme:

Weaving together aspects, organic and geometric, keeps occurring to me because I suspect a natural truth that contains many seeming contradictions. Once you begin to deal with the everchanging aspects of three-dimensional encounters the number of formal solutions is countless. The largest problem lies in the emotional choice of the most moving or the most revelatory series of experiences. The peculiar shape and qualities of the actual empty air surrounding the volumes becomes an important part of the expressiveness of the whole piece. The distance between two figures or between a figure and another object becomes crucial. My pieces often don't end at their physical boundaries. [24]

Two quite different formal systems must interlock in the large environments: the casting and completion of individual (or merged) figures, and the juxtaposition of these discrete entities with environmental objects—used without change, stripped, or simulated. Each figure, utensil, piece of furniture, or architectural element there-

14

fore has both a thematic and a formal function and position, and the spaces that separate them are calculated as precisely as mass, color, and other tangible and visible qualities. In the dialectic of the sixties between "relational" form—the juxtaposition of differing elements to make an asymmetrical structure—and primary, systematic, redundant, or random arrangements, Segal's art has remained on the relational side, and he has retained rectilinear and parallel composition, in which an actual or implied frontal plane corresponds with the picture surface in painting. In such characteristic compositions as *The Gas Station* (pages 38–39), *The Subway* (page 70), *The Parking Garage* (page 72), *The Restaurant Window* (page 69), *Girl Sitting Against a Wall* (page 71), verticals are opposed to horizontals with an austerity recalling Mondrian's works of the twenties and thirties. Although Segal begins with the figures, the environments that result from them, and their combination with other objects, become structures in the cubist-classical tradition. Just as the individual person is enclosed and perpetuated by the universalizing stamp of whiteness, the rectilinear structure associated with classicism perpetuates the momentary situation within it. In a precisely lifesize art, scale is human rather than diminutive or heroic. In relating the figures to their environment, nevertheless, they are given dominance, varying degrees of materiality, and even diminished in apparent size, as is the case with the embracing lovers in *Couple at the Stairs* (page 42).

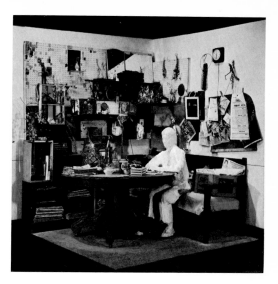

Ruth in the Kitchen, 1964

The great art of Europe, from the inner spaces of Chartres Cathedral to the austerity of Titian, reinforced Segal's penchant toward sparse compositions. It led him to remove a Pop assemblage of brightly colored advertising signs from *The Gas Station* (pages 38–39; begun before his first trip to Europe in 1964) and to strip it down to those elements "absolutely necessary and intensely expressive—there was a ruthless quality of pruning away the inessential." [25] Another elimination of surface accumulation was undertaken after completing the first version of *Ruth in the Kitchen* (1964; right; cf. page 53). Segal had permitted his subject, who lived in a cluttered environment, to arrange her own setting of books, bottles, cans, a mass of bulletin-board clippings and souvenirs, a quill pen, a broken tennis racket, dead flowers, and other hoarded rummage—an untidy collage recalling, at lifesize, the assemblages of Bruce Conner and "junk culture" at the beginning of the sixties. But the sharp image Segal wanted was inundated by the flood of decaying memorabilia. "I couldn't stand the mausoleum effect so I removed them," he recalls. "The whole thing is about Ruth's life, not her tomb." [26] In the second version (1966; page 53) he eliminated everything but the scarred dining-room table, one cup, and the divan on which the subject sits.

Fully three-dimensional sculpture has traditionally been regarded as an awkward medium for the representation of environment. Segal found a new solution to this limitation, just as his friend John Chamberlain (page 56), in assemblages of sections

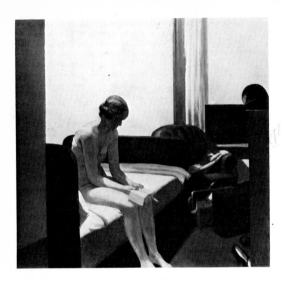

Edward Hopper: Hotel Room, 1931

of junked automobile bodies, found a new solution to the problem of polychromy in sculpture. Comparisons of Segal's situational sculpture with painting, in which figures are not wrenched from their setting, have therefore been made. Formally one of the most apt is with Jacques-Louis David's severe political compositions in which, as in Segal's works, bodily forms are simple and clearly defined (though Segal's surfaces are more painterly), furniture and architecture are stripped, spare, and thematically essential, and color is secondary to form. The late Edward Hopper, who used similarly sparse formal language in his figure paintings, was the first American artist of importance to concentrate his observation on the new environment: on lonely figures and couples in bare hotel rooms; people in lobbies, lunch rooms, barber shops, and gasoline stations. (He painted the automat in 1927.) Of Hopper I wrote in 1967, under the heading "Realist, Classicist, Existentialist," that he was "a classicist ... by virtue of an all but Davidian spareness and severity in his placing of objects, the immobility of his figures, and the severe rectilinear and parallel relationships that make up his characteristic compositional structure. His scrupulously disposed backgrounds, figures and objects, swept clean of the clutter of everyday life so dear to the genre painter, are embodiments of ideas as well as representations of ... human situations" [27] (left). "Every situation," Alvin Toffler wrote in *Future Shock*, "has certain identifiable components. These include 'things'—a physical setting of natural or man-made objects. Every situation occurs in a 'place'—a location or arena in which the action occurs.... Every social situation also has, by definition, a cast of characters—people. Situations also involve a location in the organizational network of society and a context of ideas or information. Any situation can be analyzed in terms of these five components." [28] Moreover, any situational artist—Ibsen or Beckett, Hopper or Segal—projects, whether he intends to or not, some aspects of his own life. Segal, like Hopper an intent observer of human situations, gives an added dimension to the most prosaic events and settings. "He does walk-in Hoppers," the painter Mark Rothko once remarked to Brian O'Doherty. Action subjects (as Segal's *Rock-and-Roll Combo* [page 46] and Hopper's *Bridle Path* demonstrate) fail to bring out the best in either artist. Such evident parallels call for a recognition of essential dissimilarities. Observed closely, the world of Hopper's paintings is as arid as that of Beckett's plays. Its inhabitants seem alienated from each other, unable to communicate even in the most private situations. The figures (especially the men) are stiff—almost catatonic. Their psychic numbness may symbolize, as has often been suggested, deficiencies in American social and personal relationships, but it surely also reveals Hopper's own alienation. As "the wholly unanticipated heir of Edward Hopper," Robert Pincus-Witten wrote in 1965, Segal is "the sculptor of an incommunicativeness at once dulled and contemplative." [29] He characterized the painter more accurately than the sculptor, however, for Segal's people, though like Hopper's caught within the moment of

16

time and the cubicle of space allotted to them, seem *always* to communicate with each other or, when they are alone, to commune with themselves.

Morose and taciturn, Hopper was suspicious of the rapidly changing world around him, made few close friends, and had a distaste for modernist art. His female figures, often lanky and awkward, but tense and expectant, seem to manifest (as a curious painting of a burlesque stripper suggests) a repressed need for human involvement. Segal's natural and unbiased affection for all kinds of people, and his acceptance of all kinds and levels of communication provide—more than the method of casting from life—the conditions for his art form. Not cut off from his own inner experiences, he wished, as he said in 1967, "to intensify my sense of encounter with the tangible world outside of me," and chose "an open-ended way of working" that would not "shut out any possibility."[30]

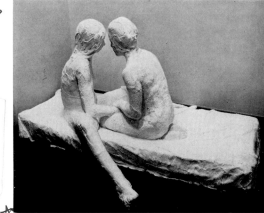

The Girlfriends, 1969

One outcome of Segal's acceptance of life is his ability to tackle the delicate subject of love and sexuality without evasion or prurience. Among his pairs of lovers is *The Girlfriends* (1969; right), a tremulously sensitive portrayal of lesbian affection. Anything but sensational, the poses (as Segal insisted) are restrained, and eroticism is no more than suggested. The girl at the left of the narrow cot (included in plaster as a sculptural unit with the figures, as is the bedding in *Lovers on a Bed II*, 1970; below) sits in an entreating, open-legged position, seemingly fearful of rejection. The pose of the other girl is closed, protective, and reluctant, as if to restrain the timorous eagerness she faces. In the somewhat less problematical groups of heterosexual lovers protectiveness, tenderness, united repose, and inner communion are more at issue than sexuality, but Segal has experimented with more overtly sexual situations. If only because of the complex responses they raise both in himself and in the average spectator, they are difficult to handle and subject to misinterpretation. Unlike Rodin, Segal does not employ the device of romantic idealization to transcend the controversiality of sexual subjects, but he has made a carefully considered contribution toward the liberation of plastic art from taboos already shattered for the novel, theater, and film. Entirely free of the Pop erotics of such artists as Tom Wesselman, Mel Ramos, and Frank Gallo, his couples are sentient beings rather than objects, media hybrids, or sentimental fantasies. In both the lovers groups and the female nudes (right), Segal has closed the gap between the representation of physical love and more commonly and forthrightly treated human subjects. Only in one work, *The Legend of Lot* (page 60), is a controversially sexual theme legitimized by a moralistic pretext. It was included (accompanied by an enlarged photocopy of the text from the nineteenth chapter of Genesis on which it was based) in an exhibition of allegedly erotic art at the Janis Gallery in 1966. The critic of *The New York Times*, it appeared from his review of the exhibition, was in too much of a hurry to take note of the theme (though Lot's wife, represented as a pillar of salt, formed a part of the group). "George Segal's plaster lovers,"

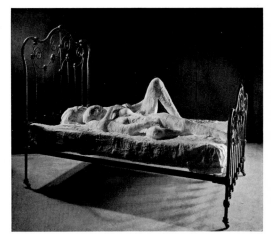

Lovers on a Bed II, 1970

Mr. Canaday wrote, "have a plaster voyeur alongside."[31] *The Legend of Lot*, however, was not a modish exploitation of this universally tabooed relationship. Segal had been haunted by the Biblical story for years, and had painted five versions of it before he became a sculptor. His strict early training, in which "work and duty came first," led him to identify the freedom of art with that of sex, especially after this conditioning was challenged by the libertarianism of the bohemian friends he met as a developing artist. The tale of Lot, a God-fearing and moral man who twice performed incestuous acts while drunk with wine, posed a dilemma for Segal: could this father really have been too drunk to realize his husbandless daughters had entered his bed, and still have retained the potency to impregnate them both? Was he, as the text suggests, the innocent victim of his daughters' desperate scheme to perpetuate his name, or was he a lecherous, incestuous conniver?

Although it is in part because his friends, neighbors, and family have been his favorite and most available subjects that Segal's work has an autobiographical dimension, it is evident, as *The Legend of Lot* demonstrated, that there are more deep-seated causes. *The Butcher Shop* (1965; page 51) was undertaken as a memorial, six months after the death of his father, who was a kosher butcher. Segal's mother was induced to pose standing at the chopping block, cleaver in hand, about to dress a chicken—a stigma that deeply marked his childhood and youth. During the sittings, he recalls, her previous life passed through her mind incident by incident. The *mise en scène* is especially sparse, schematic, and rigorously rectilinear. Eschewing the agitated expressionism of Soutine's paintings of fowl and sides of beef, Segal transforms ineradicable memories of his daily encounters with the cultivation, slaughter, and dismemberment of poultry, and its inseparability from Jewish culture, into a solemn but outwardly tranquil ceremony.

Entirely different in spirit and content, though as intimately connected with his own life, is the unique and problematical group *The Costume Party* (1965; pages 58 and 59). It is made up of six arbitrarily colored figures in odd, theatrical costumes. They coexist in a mystifying confrontation, to effect a mood of ominous rituality and incipient violence. Although Segal now regards this work as "an ambitious failure," it nevertheless exemplifies his unwillingness to be bound by earlier solutions, and his continous drive to extend the range of experience and the kinds of subjects for which his medium can be made appropriate. Undertaken during a period when he was in a "bad state of mind," any one of his friends who by chance walked through his door was "just grabbed" as a subject, and induced to pose in costumes that projected a *dramatis personae* extracted from Segal's own fantasies, dreams, and nightmares. (In one, he entered his suite of workshops to find that the plaster figures from various groups had come to life.) *The Costume Party* includes a seated cat-woman wearing a yellow feather mask, a reclining, contemporarily clothed Cleopatra on whose lap a Mark Antony in chinos, helmet, 18

holster, and cartridge belt rests his head; and "Pussy Galore" (a predatory female motorcyclist in helmet and boots, antiheroine of a movie then current). A tall, sedately robed figure which, like Bottom in *A Midsummer Night's Dream*, wears an ass-head mask, fixes the two standing figures at the right with a steady gaze: Pussy Galore and a young, heavy-bellied buck wearing only an oval-framed portrait of himself on a cord around his neck and, around his waist, a surrogate penis—symbol of masculine aggression. Here Segal was concerned with "the facts of bodies" as a means of probing such components of subjectivity as dreams, nightmares, libido, aggression, tensions, anxieties, and situations internalized from literature and history. Shakespeare and Surrealism, and perhaps Happenings and the theater of the absurd, were in his mind. Although he does not see himself as a Surrealist, he recognizes that it was Surrealism that dealt most successfully with such subjects. Clearly revealed, if not fully mastered, is the characteristic but usually muted Dionysian undercurrent of Segal's art. "This is the first time I ever used friends ruthlessly to project my own dark state of mind.... The bright colors added somewhat to the nightmare qualities of the piece."[32]

Expanding his range of subjects beyond his circle of family, fellow artists, and other friends but still using them as models, Segal has represented a variety of situations and professions, among them a tightrope walker, a trapeze performer, a farm worker, a pair of Bowery bums, a billboard painter, a parking garage attendant, a roofer, a dentist, a ticket-taker, bus drivers and passengers, and people in restaurants, hotels, bars, the telephone or photo booth, or simply standing in doorways, waiting in the laundromat or bus station, walking, idling, or hustling in the streets. One figure of 1970 represents a nude bather against the surface of the water from which she emerges—a self-contained work of sculpture that successfully represents nature and excludes environmental objects (page 79); another, an actress (right) whose classicizing costume somehow impairs the inherently classical character of more ordinary subjects. The four dead bodies of *Execution* (1967; page 67)—one suspended head downward as was the corpse of Mussolini—question the possible fate of the aggressors in Vietnam.

Segal has also remained aware of new technical and formal possibilities. From the moment that his distinctive method was initiated, he has continued to probe its potentialities and limitations. As a painter he used a full palette; despite his attachment to white figures, he has never abandoned strong color, which he plays against the figures in objects and architectural elements. Large wall areas and environmental elements introduce strong planes of blue, red, yellow, black, and, less often, orange and green. They complement the white figures, profoundly affecting their scale, dominance, and effect of mass. In some cases color, like illumination, is used to flatten or dematerialize these sculptural qualities. Color and light for Segal, in addition to enrichment and illumination, are modes of distinguishing

19

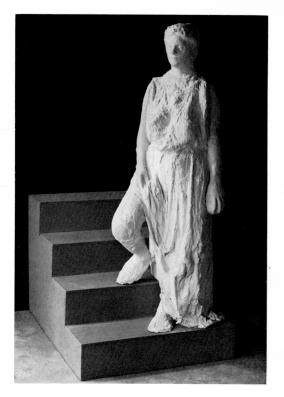

The Actress, 1965

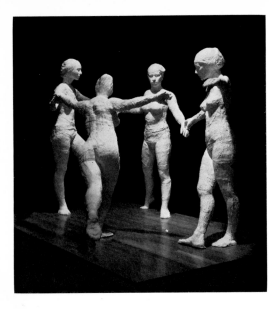

The Dancers, 1971

matter from spirit—of extending the penumbra of meaning that surrounds any situation drawn from experience. He has used electric illumination in several ways: the worker in *Cinema* (1963; page 37) is silhouetted against a large electric sign; in *Man on Ladder* (1970) the huge, glowing "W," by contrast, solidly models the precariously leaning figure; *The Moviehouse* (1966–67; page 65) employs a ceiling banked with some 300 light bulbs; *The Dry Cleaning Store* (1964) is structured by a frontal plane of red and blue neon. In *The Aerial View* (1970; page 86) a lonely figure, seen from the rear, looks out on a sweeping nocturnal panorama, evoked by a black background perforated by transparent pegs of colored plastic that beam dots of light from the rear, combining flatness and deep perspective in an illuminated pointillism. Film projection was used in *The Truck Driver* (1966) and *The Restaurant Window* (1967; page 69) to extend the environment into the outside world. Other works incorporate sound: a record player in *Woman Listening to Music* (1965; page 48) and a tape recorder in the austerely geometric *Alice Listening to Her Poetry and Music* (1970; page 84). Not all of Segal's ventures into untried technical, formal, and thematic territory are equally successful, but their combined effect has been to keep his art vital, and increase its range, while retaining virtues inherent in the initial statements of 1962.

Innovative though Segal has been during the last ten years, his accomplishments do not rest only on the casting method and environmentalism. At the core of his achievement is his increasing mastery of expressive figure sculpture, which can be judged by wholly traditional standards. Now at mid-career, each year his understanding of the body as a medium has increased. It is significant that a recent group, *The Dancers* (left; a veristic recognition of Matisse's masterworks of 1909–10), as well as earlier representations of theatrical and circus subjects, deals with the arts of bodily expression. Never overnuanced, Segal's treatment of the figure has nonetheless become more and more refined; yet he has wisely retained the casting *method* because it insures veracious morphology and gesture, and the casting *situation* because it breaks through the sitter's restraints, to reveal authentic personhood. Like no other sculptor he can make a rounded body melt (as in the superb *Sleeping Girl* of 1969) into an embracing topography of bedding; dramatize the weight of a heavy figure or the ephemerality of thinness; simulate the worn, rumpled jeans of a worker leaving a bus; or delineate the hard contours of a buttock as against the fragile rotundity of a breast. The bone-and-flesh articulation of hands, wrists, thighs, calves, and ankles is powerfully but delicately accented, and the smallest gestures are knowingly conformed to pose and theme. It is a delight, finally, just to study the surfaces of Segal's figures—an amalgam of clean contours, plainly exposed gauze patches, flows, drips, and sharp-edged beads of plaster—a contradictory medium that at various stages in its drying cycle can be as liquid as cream, a responsive paste, or a solid that can be worked by rasping, carving, 20

and other dry-surfacing methods. Segal's increasing mastery of plaster has utilized its entire range, giving form in one more way to the dialectic by which, at every level, he approaches his art.

As his drawings, pastels, and prints demonstrate, Segal has always been moved by the expressiveness of isolated portions of the body, but it was not until 1970 that he showed partial figures (below right). These lyrically beautiful, entirely sculptural works not only focus his powers as a sculptor, but show his ability to advance by concentration as well as diversification. Entirely contemporary, they nevertheless resemble fragments from ancient pediments or stelae. They recall the Grecian origins of Western figure sculpture, a tradition in which Segal will surely have a place.

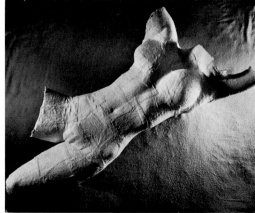

Top: Fragment: Lovers II, 1970
Bottom: Untitled Fragment, 1971

21

Notes

1 Barbara Rose and Irving Sandler, "Sensibility of the Sixties," *Art in America*, Vol. 55, No. 1, January-February, 1967, p. 55.

2 The Reuben Gallery was not, as its name might indicate, a typical art exhibition space, but an improvised theater for unconventional art activities. Its existence was preceded by a series of events held at the Judson Memorial Church in Greenwich Village, and it was at first located in a loft at Fourth Avenue and Tenth Street, where Kaprow's *18 Happenings in Six Parts* was presented in 1959. The "Gallery" moved next to Second Avenue and Second Street in the East Village, and finally to a dilapidated store at Second Avenue and Third Street. Here it became the scene of the now historic series that established the Happening as a recognized art form.

3 See Alfred H. Barr, Jr., *Matisse: His Art and His Public*, New York, The Museum of Modern Art, 1951, pp. 336–57.

4 Henry Geldzahler, "An Interview with George Segal," *Artforum*, Vol. III, No. 2, November, 1964, p. 26.

5 Unidentified quotations are from conversations or correspondence between Mr. Segal and the author.

6 This statement is based on one that appeared in *Newsweek*, October 25, 1965, p.107, but it has been expanded, and corrected in certain details, by the artist. The Johnson and Johnson Company, a manufacturer of bandages, is located in New Brunswick, near Segal's farm. His student, the wife of a Johnson and Johnson chemist, brought samples of the new product to class in the hope that her teacher could be induced to write a pamphlet on its application to craft projects. As Segal says, he "found out something to do with it."

7 Robert Pincus-Witten, "George Segal As Realist," *Artforum*, Vol. V, No. 10, June, 1967, p. 85.

8 *Time*, December 13, 1968, p. 84.

9 William C. Seitz, ed., *São Paulo 9* [The United States Exhibition at the São Paulo Bienal], Washington, The Smithsonian Institution Press, 1967, p. 103. Quoted from a lecture by Segal given at the Albright-Knox Art Gallery, Buffalo, New York, February 28, 1967.

10 From a letter to the author, November 16, 1970.

11 Each year after 1964 has added nuances of meaning, both aesthetic and social, to the Pop Art movement. Plainly, it was not simply a naive or venal capitulation of artists and dealers to the market and the Media, as its early detractors held it to be, nor was it as profound a comment on contemporary life as it appeared to some of its spokesmen; nor did it collapse like a punctured balloon by 1965, as has been said, with the advent of newer art fashions. Both the meaning of Pop and the thrust of Post-Pop and Radical Realism have evolved with the rapidly increasing tensions of the decade. The initial premises of Pop can now be seen, indeed, as a denigration of capitalist values and practices as well as submission to them.

12 Allan Kaprow, "Segal's Vital Mummies," *Art News*, Vol. 62, No. 10, February, 1964, pp. 30–33 and ff.

13 For illustrations of these figures, see Marcel Brion, *Pompeii and Herculaneum: The Glory and The Grief*, New York, Crown, 1962, pp. 34, 48; also Jan Lukas and Sir Mortimer Wheeler, *Pompeii and Herculaneum*, London, Spring Books, 1966, pp. 18–25.

14 See Karl Aschenbrenner and Arnold Isenberg, *Aesthetic Theories: Studies in the Philosophy of Art*, Englewood Cliffs, Prentice-Hall, 1965, pp. 403–12.

15 Seitz, *op. cit.*, pp. 102–3.

16 For the bronzes made from these works after Degas's death, see John Rewald, *Degas: Sculpture, The Complete Works*, New York, Abrams, 1956, pp. 24–29, 76–78, 81–82. The original of the *Petite Danseuse* was modeled in wax, three-quarters lifesize, and wears, beside a *tutu* and hair ribbon, a real cloth bodice covered with a thin layer of wax, and real slippers. It was shown in the 1881 Impressionist Exhibition—the only sculptural work Degas exhibited during his lifetime. " 'The result is almost frightening ...' wrote Paul Mantz in *Le Temps*. 'The wretched child stands in a cheap gauze dress, with a blue ribbon around her waist [sic] and shoes on her feet.... Terrifying, because she is without thought, she brings forward, with bestial impudence, her face or rather her little phiz ...'. " (Rewald, p. 18). Almost all of Degas's waxes, including those mentioned in this text, are in the collection of Mr. and Mrs. Paul Mellon.

17 From *Prothalamion*. See *The Poetical Works of Edmund Spenser*, New York, Crowell, n.d., p. 643.

18 Robert Graves, *The White Goddess*, New York, Creative Age, 1948, p. 360.

19 In *Black Or White* [Catalogue of the Kootz Gallery, New York], 1950.

20 It seems worth noting that direct construction in plaster, applied over chicken wire, burlap, and other structural and reinforcing materials, was a common technique used by certain of the most advanced sculptors employed on the Works Projects Administration in New York during the 1930s. In the sixties Peter Agostini, for one, carried forward this method in bold, innovative works using inflated balloons and inner tubes as forms—an abstract parallel, also produced by an original casting process, to Segal's figurative plaster sculpture.

21 Duchamp's comment was made in a handwritten and signed statement reproduced in the catalogue of Segal's 1965 exhibition at the Janis Gallery, New York.

22 Geldzahler, *op. cit.*, p. 27.

23 Bruce Glaser, "Questions to Stella and Judd," *Art News*, Vol. 65, No. 5, September, 1966, p. 58. This contrast of the attitudes of Segal and Stella toward content was first made by Jan van der Marck in his introduction to the catalogue of the exhibition *George Segal: 12 Human Situations*, Museum of Contemporary Art, Chicago, 1968.

[24] Geldzahler, *op. cit.*, p. 29.

[25] *Ibid.*

[26] Bryden Smith, ed., *Dine, Oldenburg, Segal* [Exhibition Catalogue of the Art Gallery of Toronto], 1967, p. 65.

[27] Seitz, *op. cit.*, p. 19.

[28] Alvin Toffler, *Future Shock*, New York, Random House, 1970, p. 32.

[29] Robert Pincus-Witten, "New York," *Artforum*, Vol. IV, No. 4, December, 1965, p. 53.

[30] Seitz, *op. cit.*, p. 102.

[31] *The New York Times*, Tuesday, October 4, 1966, p. 54. In justice to Mr. Canaday it should be added that, in a laudatory review of Segal's exhibition at the Janis Gallery in 1971 (Sunday, April 25, Section 2, page 19), he responded with approval and understanding to *Lovers on a Bed II*, describing them as "shown in postcoital sleep with genitalia fully and naturally revealed," and called attention to the affinities of Segal's sculpture to the work of Degas.

[32] Bryden Smith, *op. cit.*, p. 69.

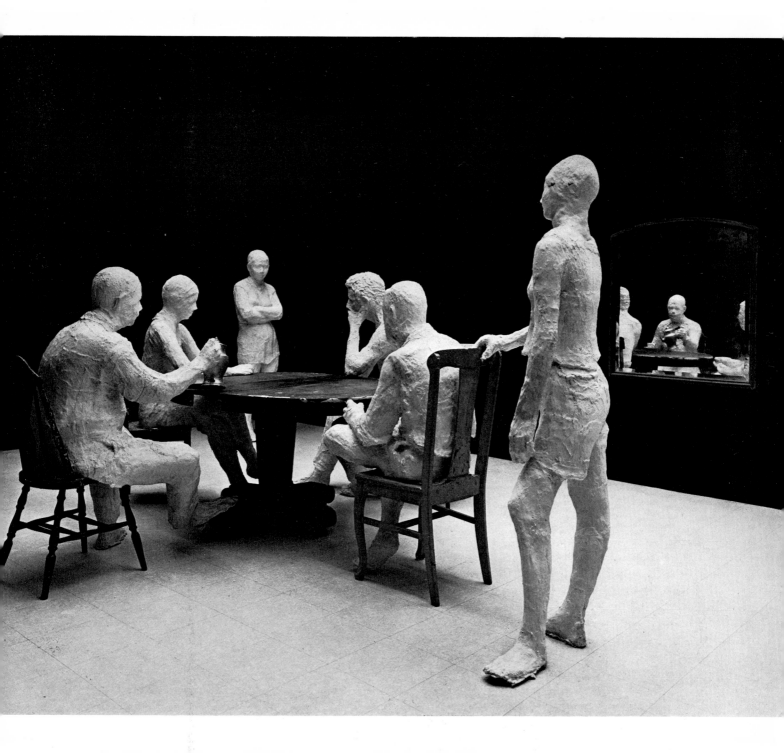

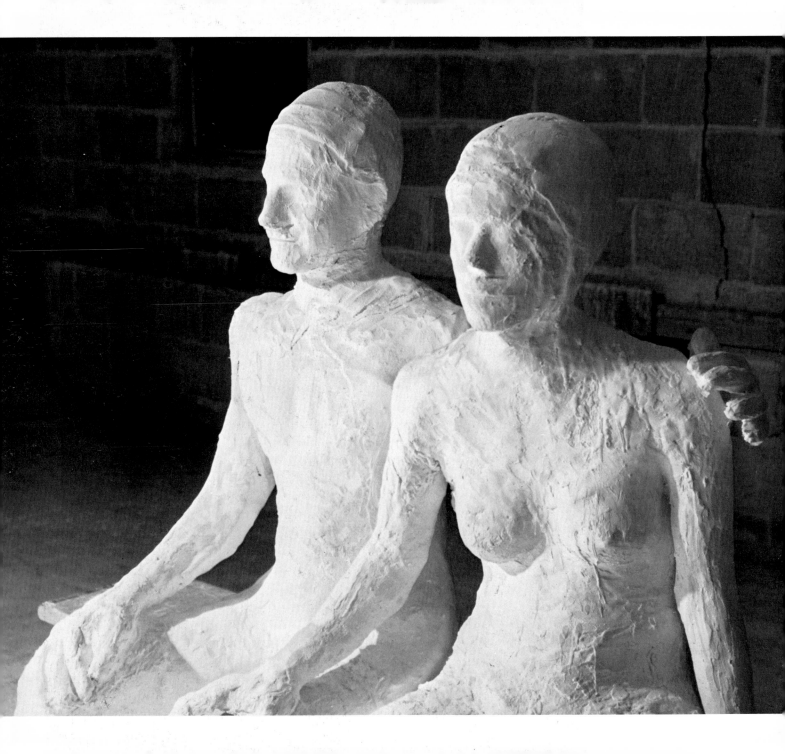

Lovers on a Bench, 1962

Bus Riders, 1962

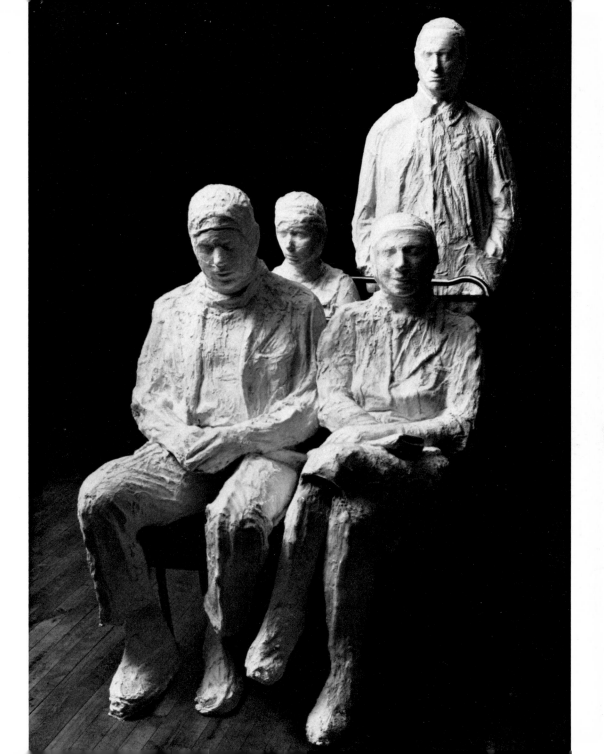

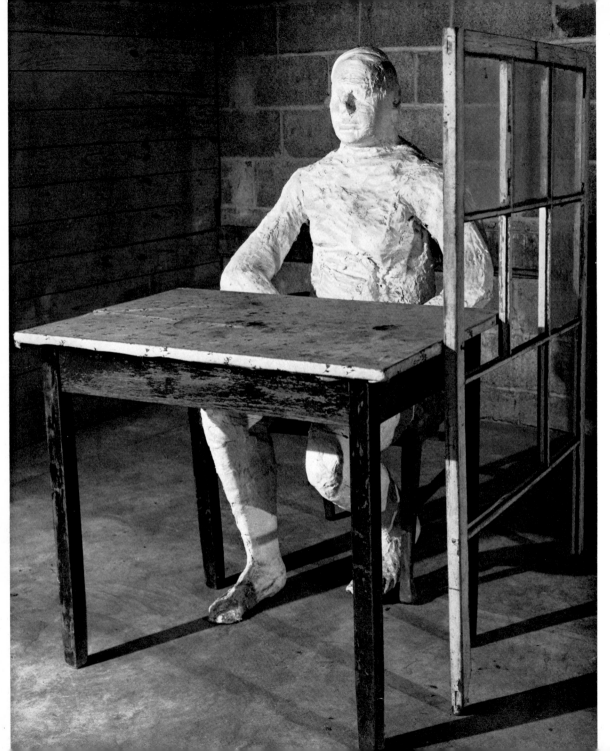

The Man at the Table,
1961

Woman
in a Restaurant Booth,
1961–62

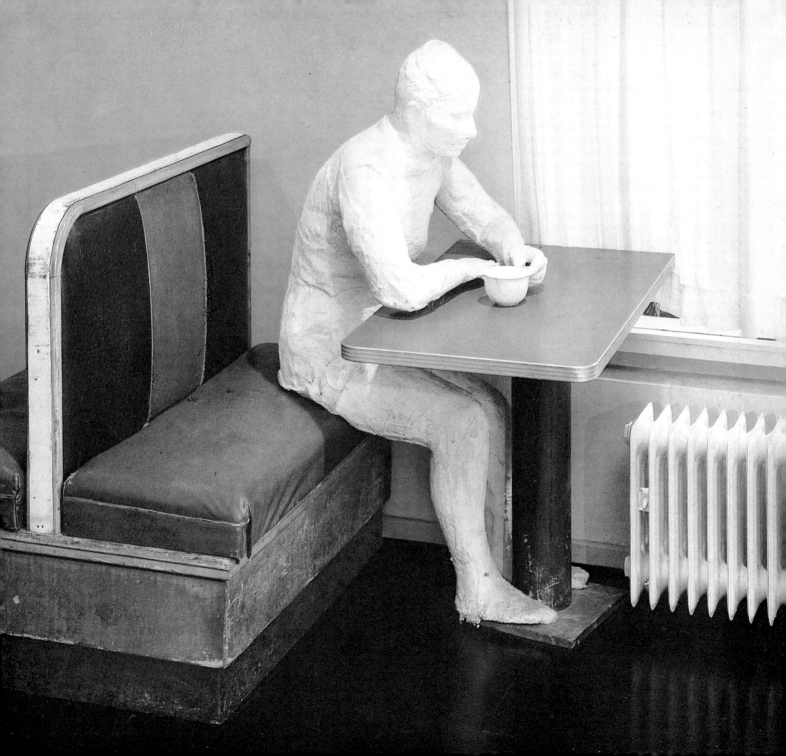

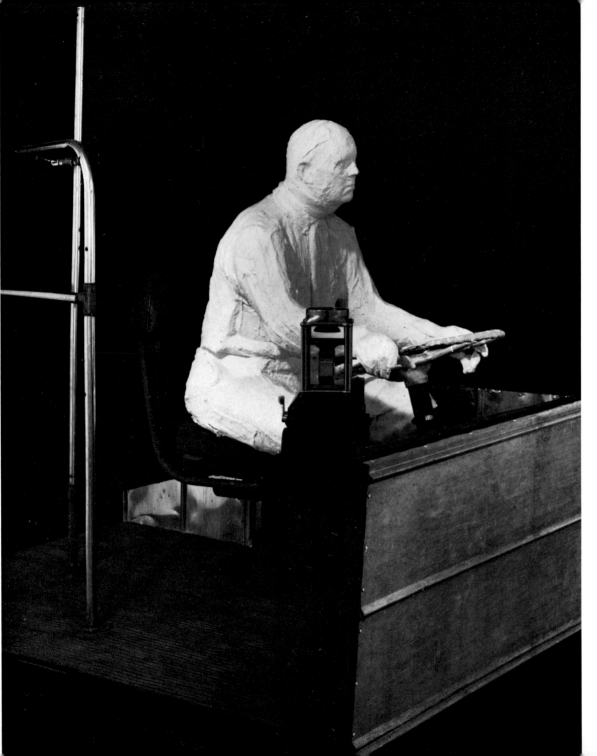

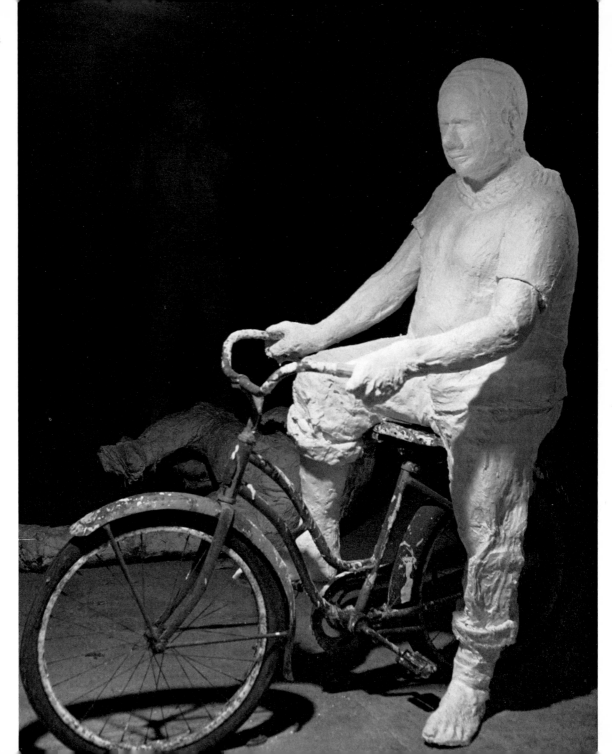

Man on a Bicycle, 1962

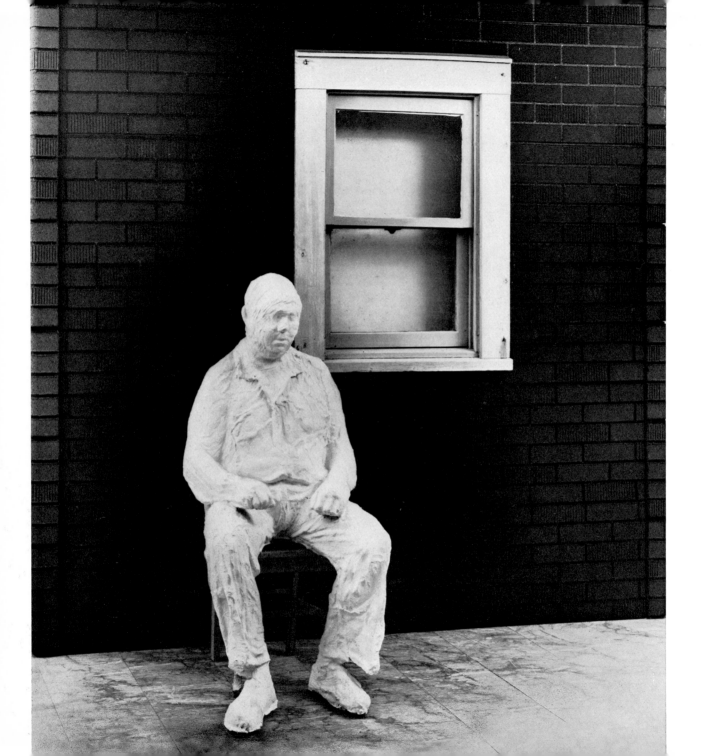

The Farm Worker, 1962–63

Man
Leaning on a Car Door,
1963

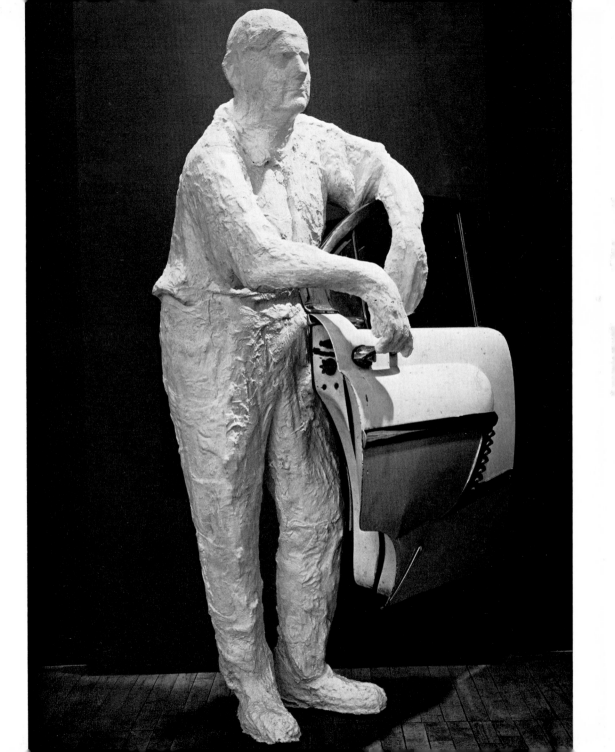

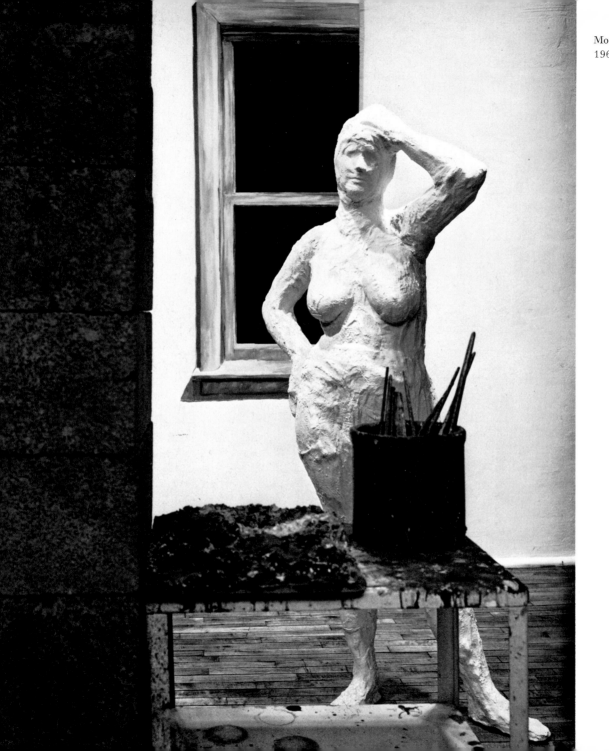

Model in the Studio,
1963

34

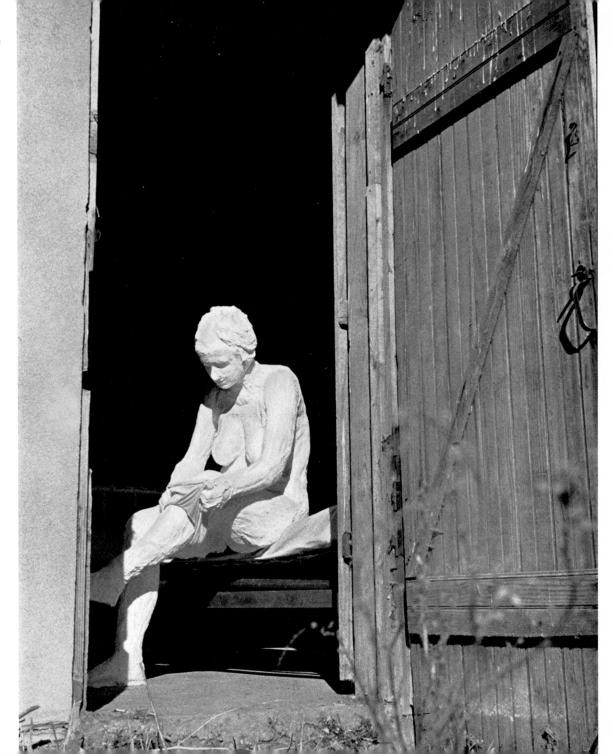

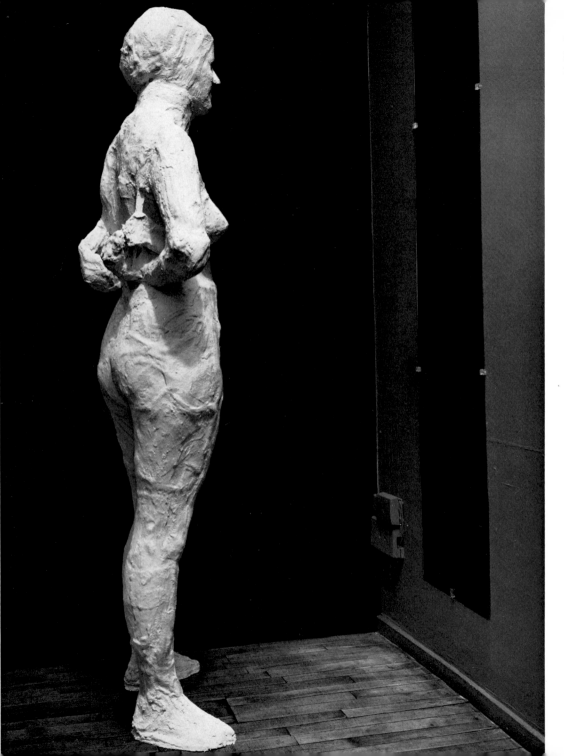

Woman
Buckling Her Bra,
1963

Cinema, 1963

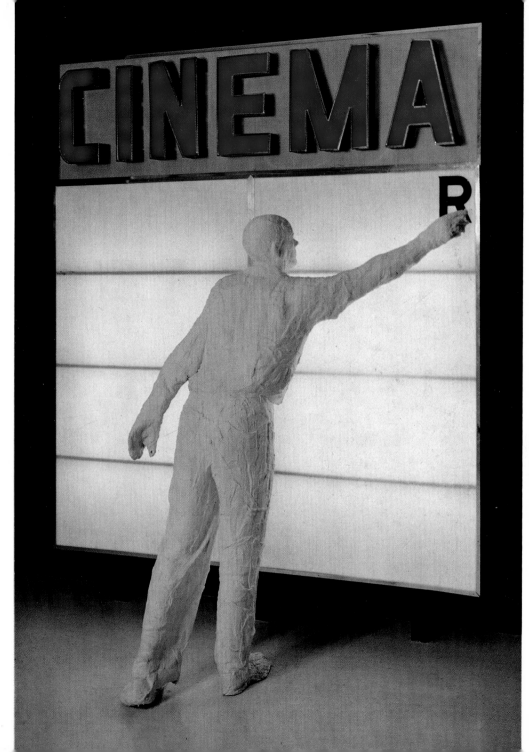

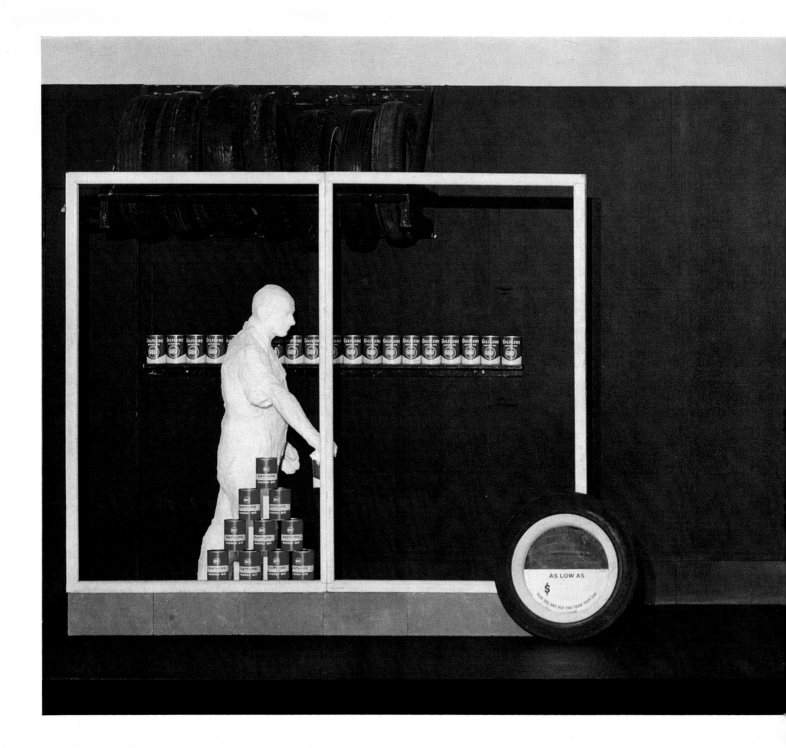

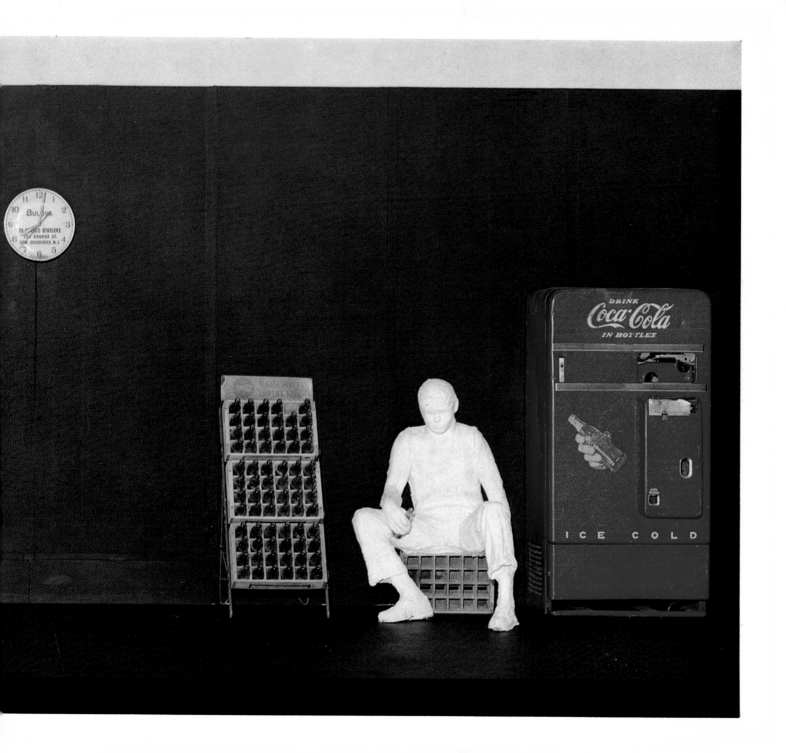

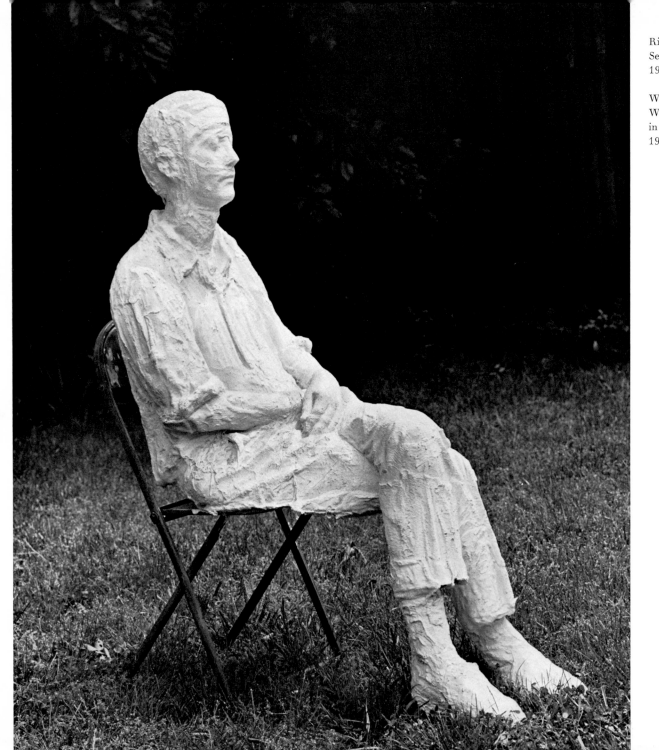

Richard Bellamy
Seated,
1964

Woman
Washing Her Foot
in a Sink,
1964-65

40

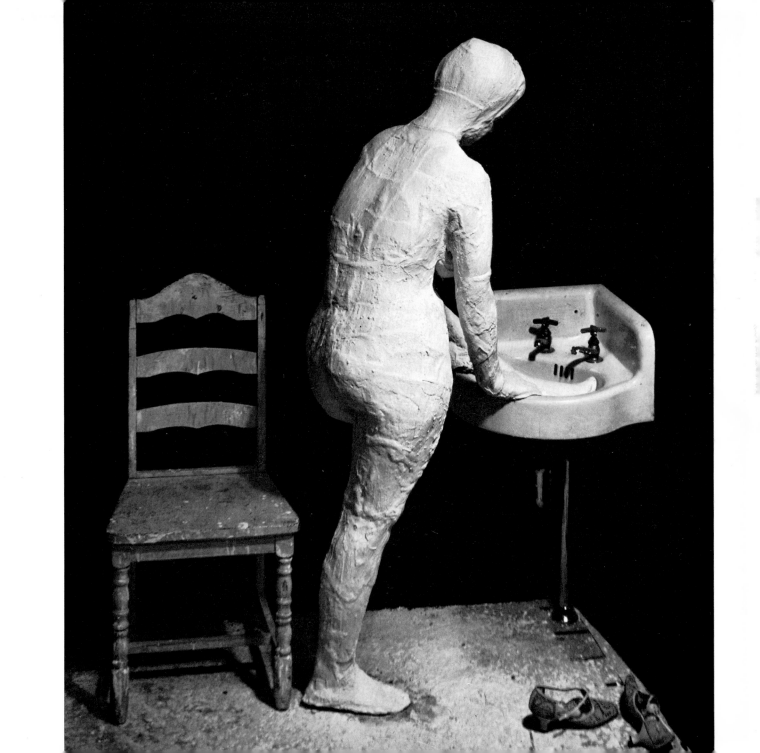

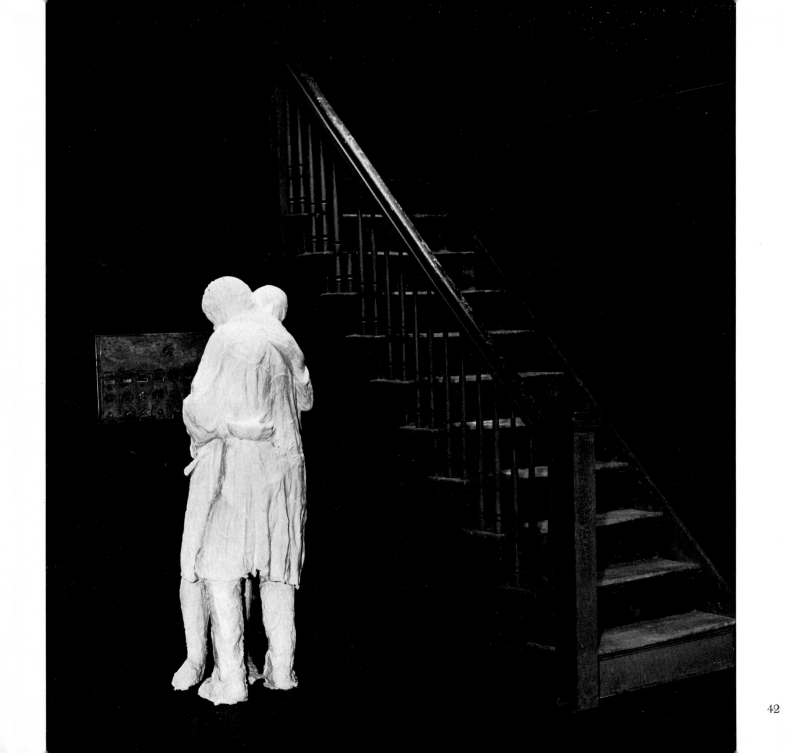

42

Couple at the Stairs, 1964

Girl in a Doorway, 1964

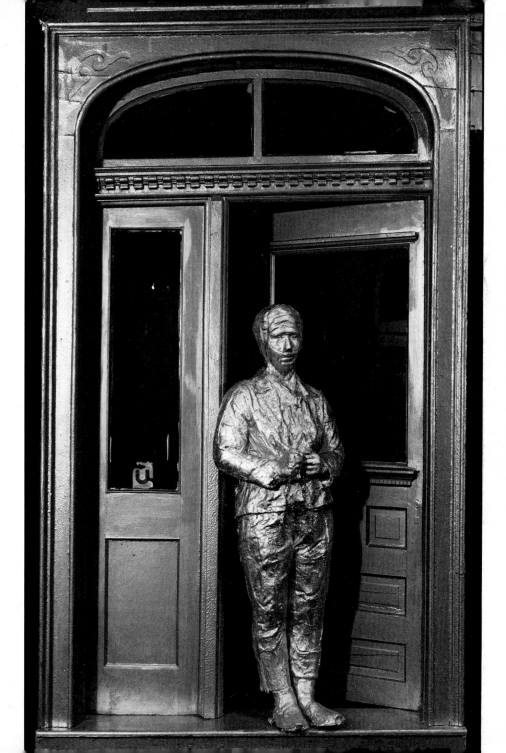

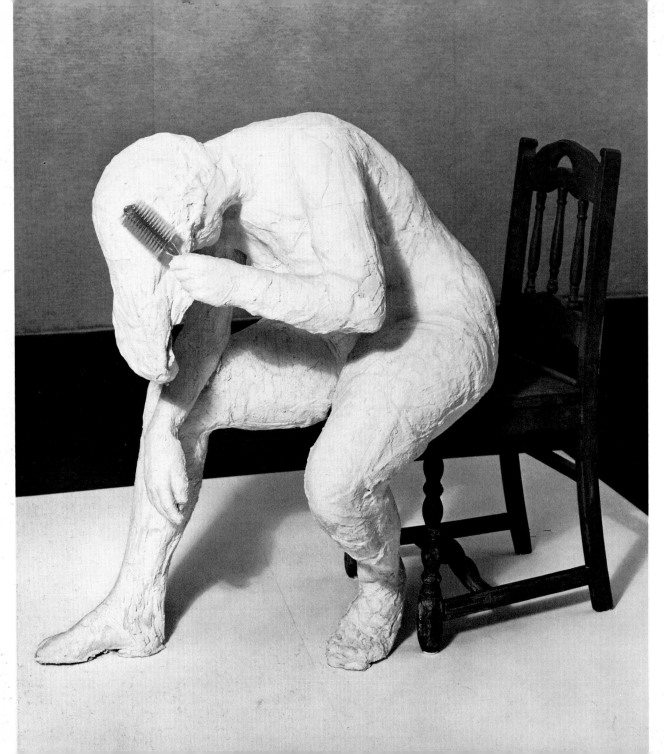

Woman
Brushing Her Hai
1965

Woman
Shaving Her Leg,
1963

44

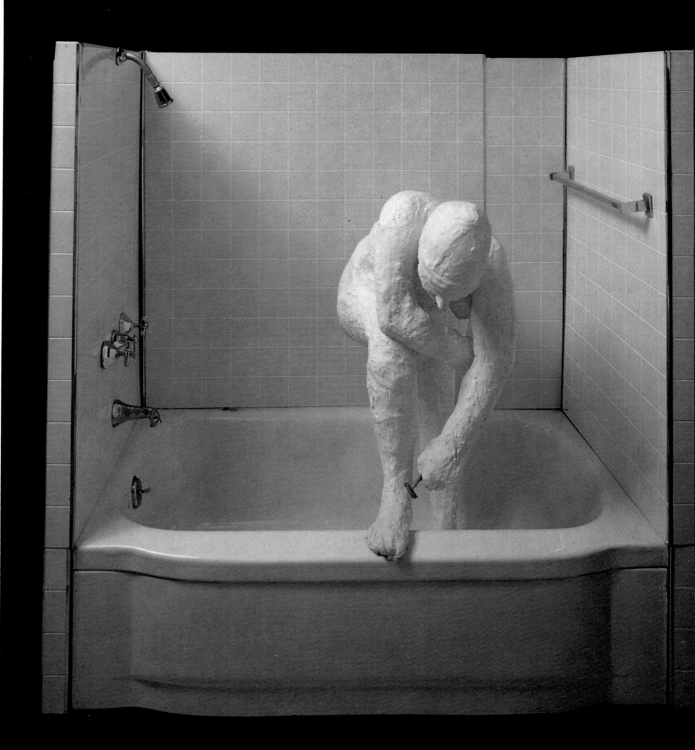

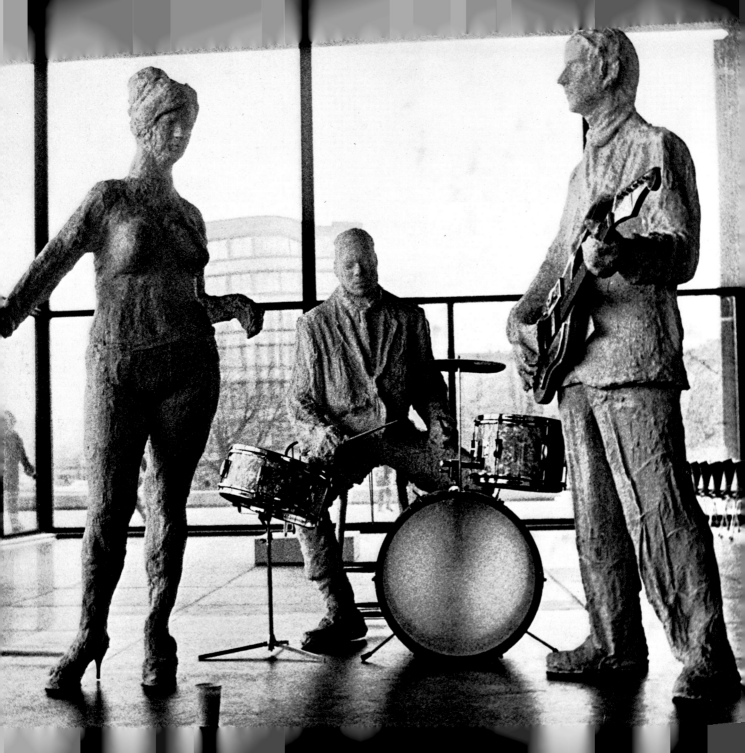

Rock and Roll Combo, 1964

Woman in a Doorway II, 1965

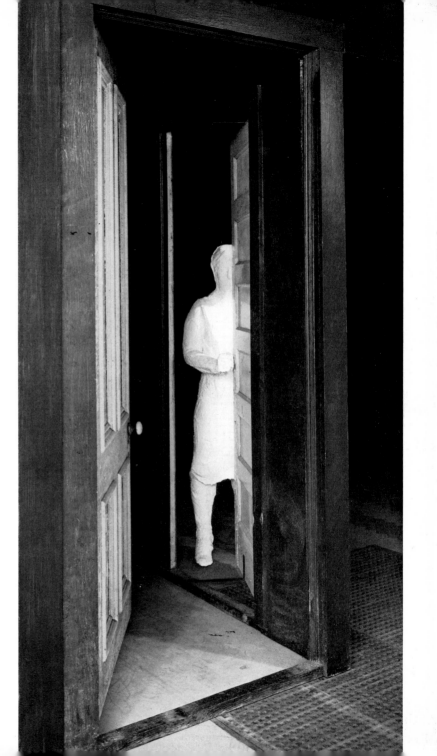

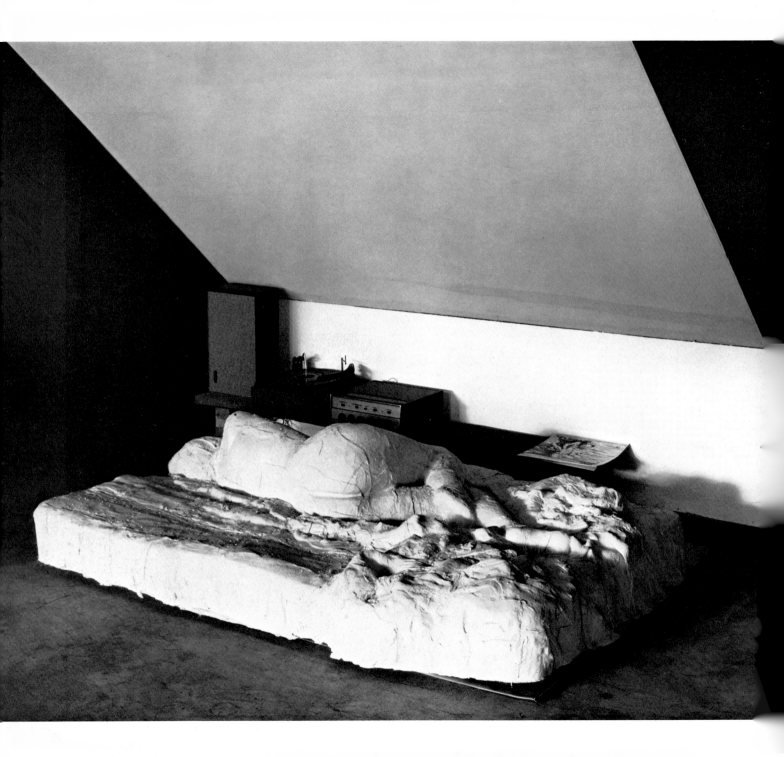

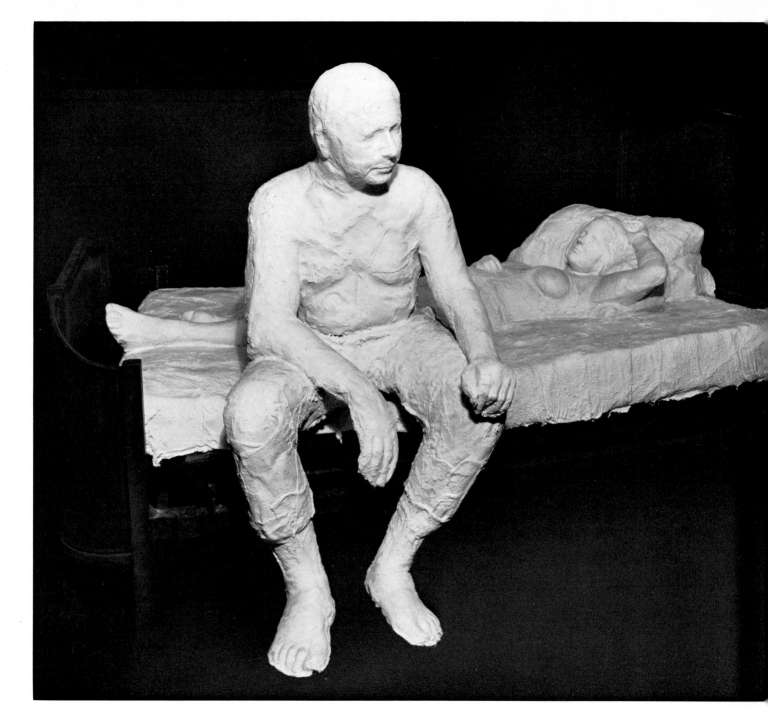

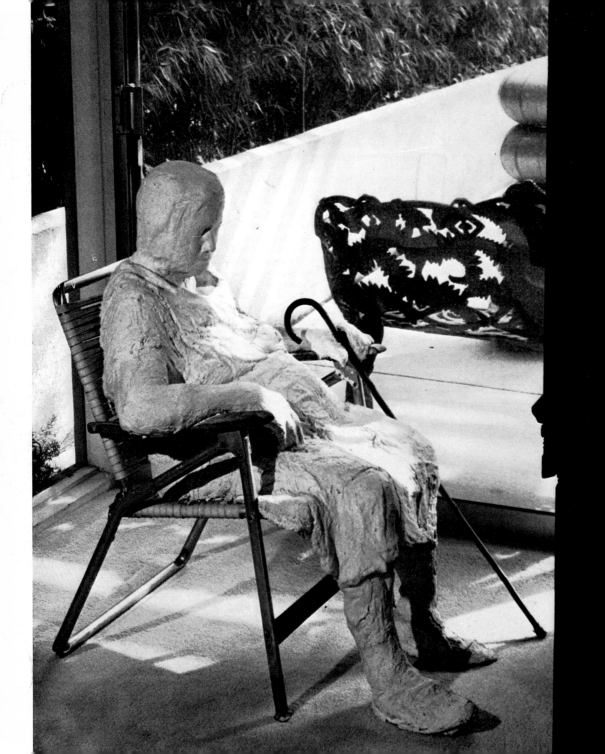

Old Woman at a Window,
1965

The Butcher Shop, 1965

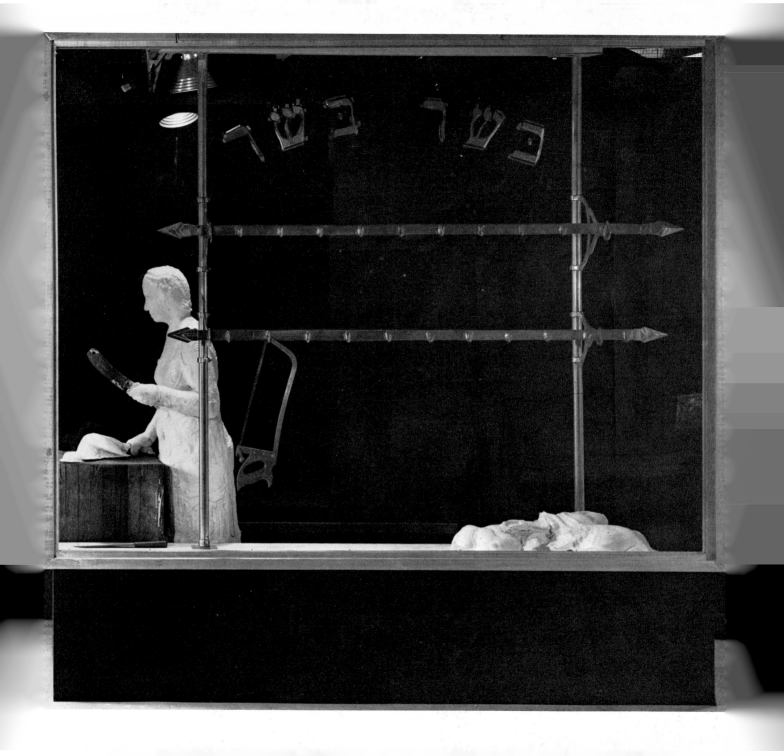

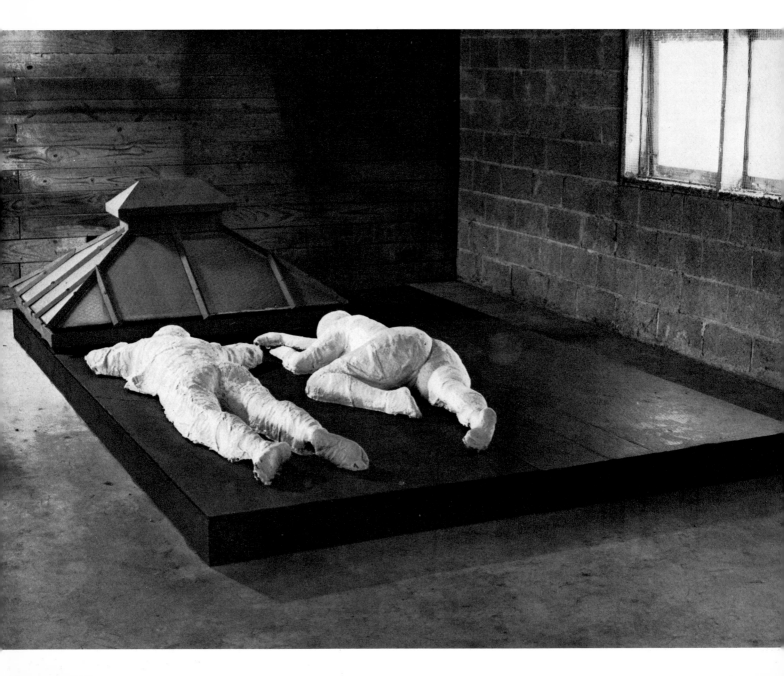

Sunbathers on Rooftop (New Version),
1963–67

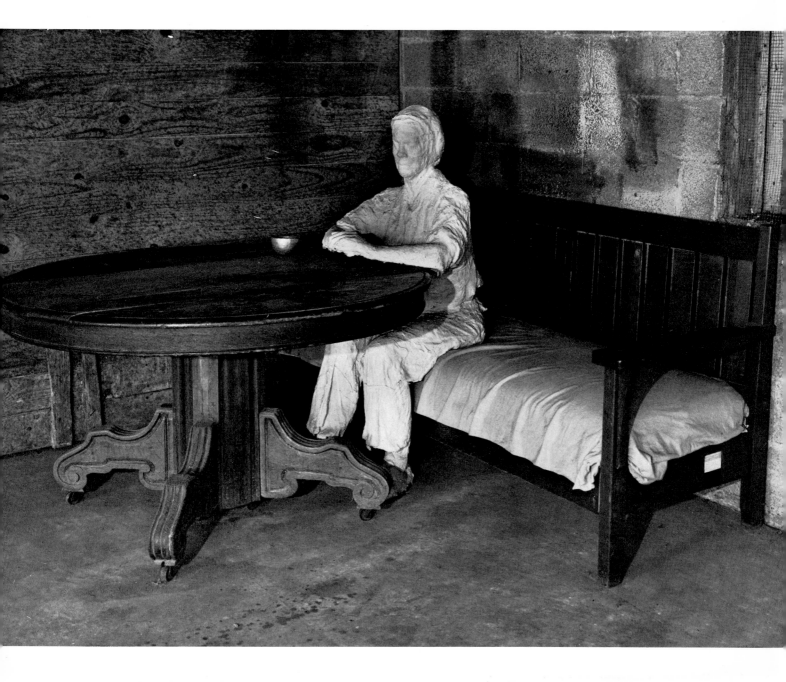

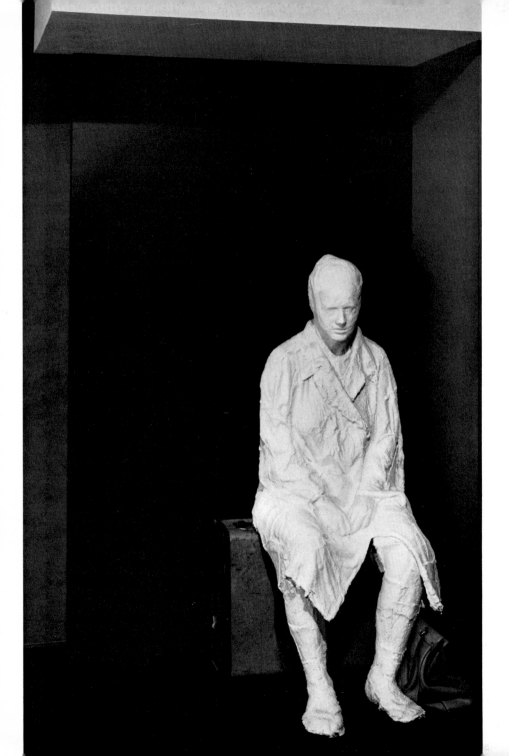

The Bus Station, 1965

The Photobooth, 1966

54

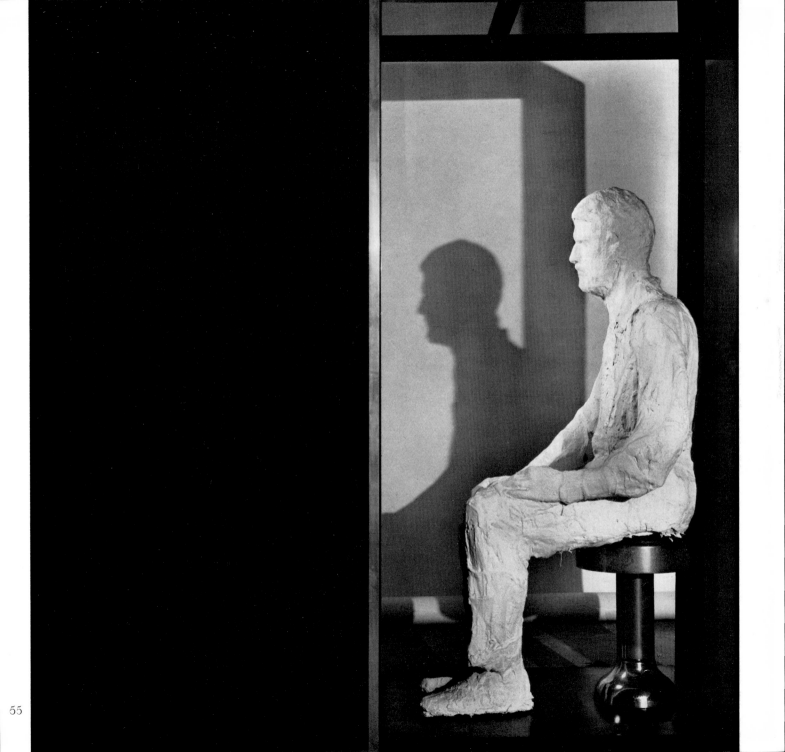

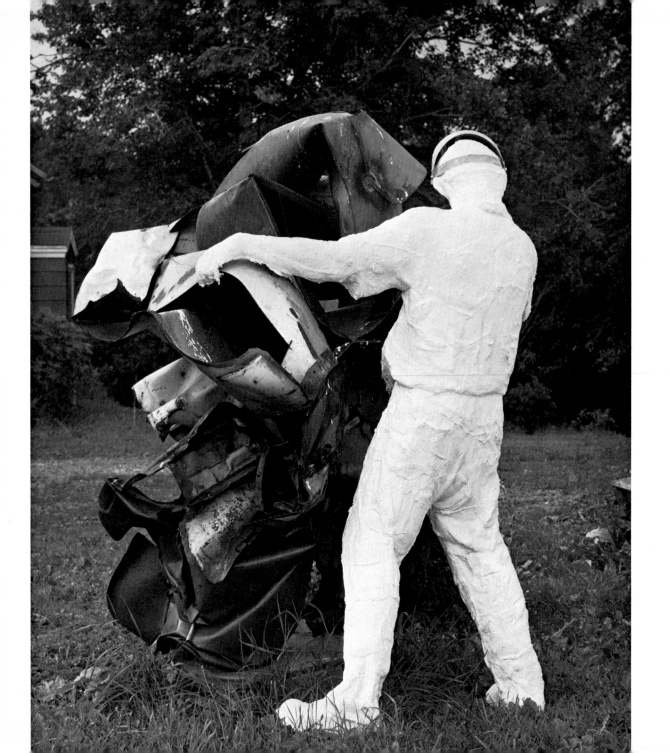

John Chamberlain Working,
1965–67

Walking Man, 1966

57

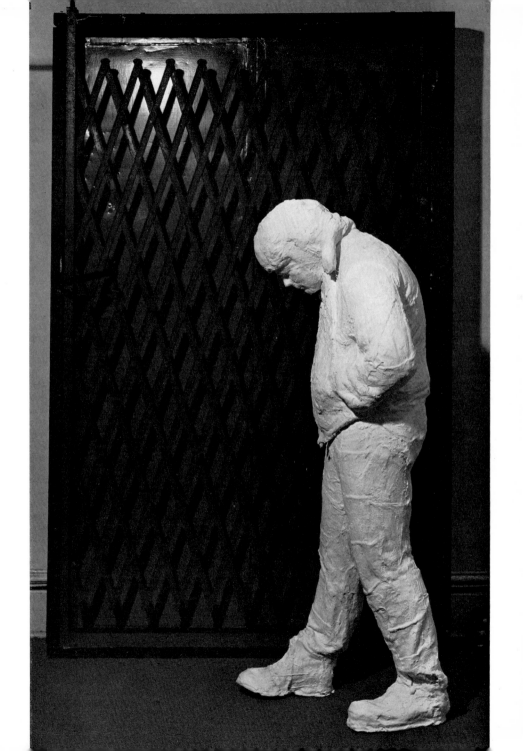

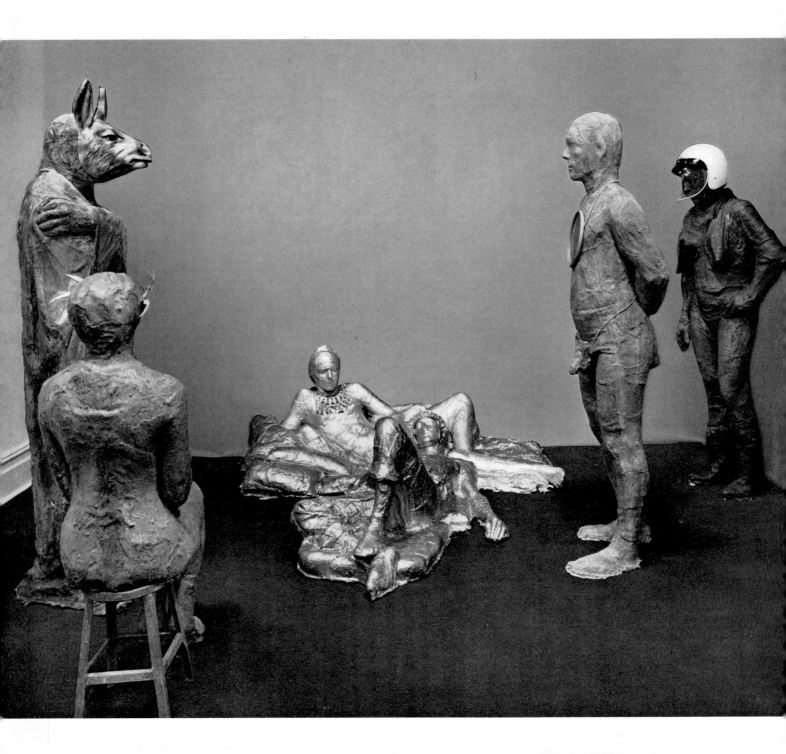

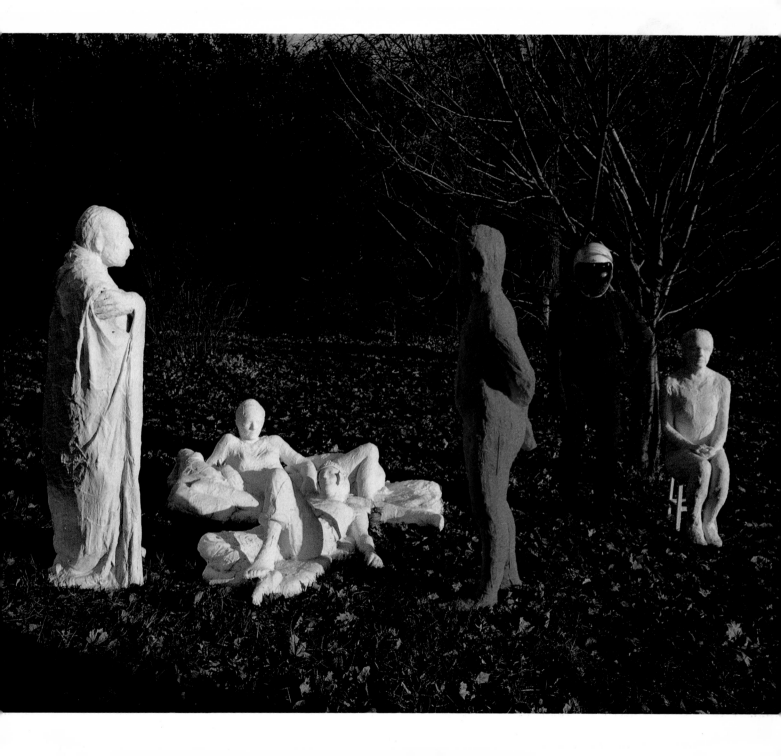

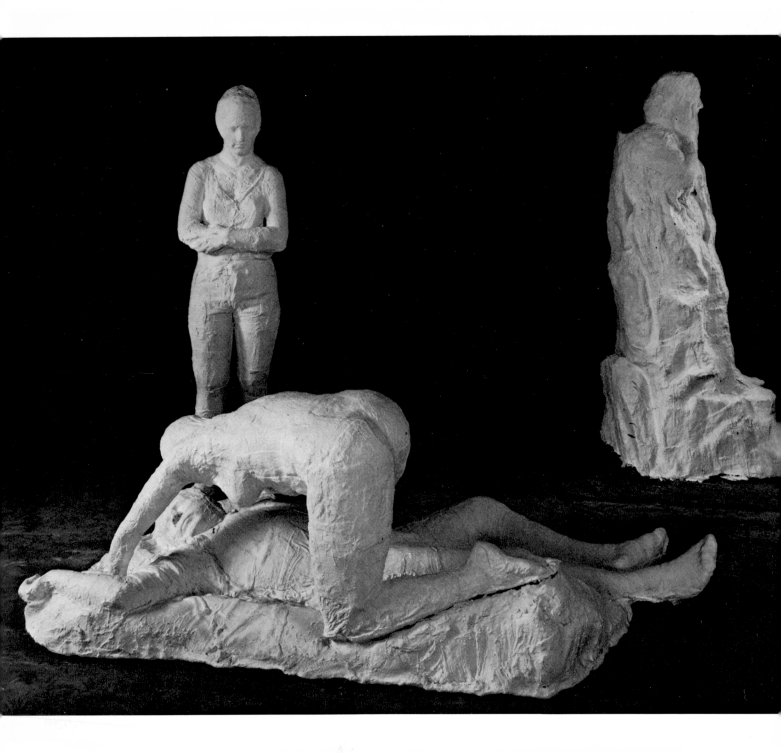

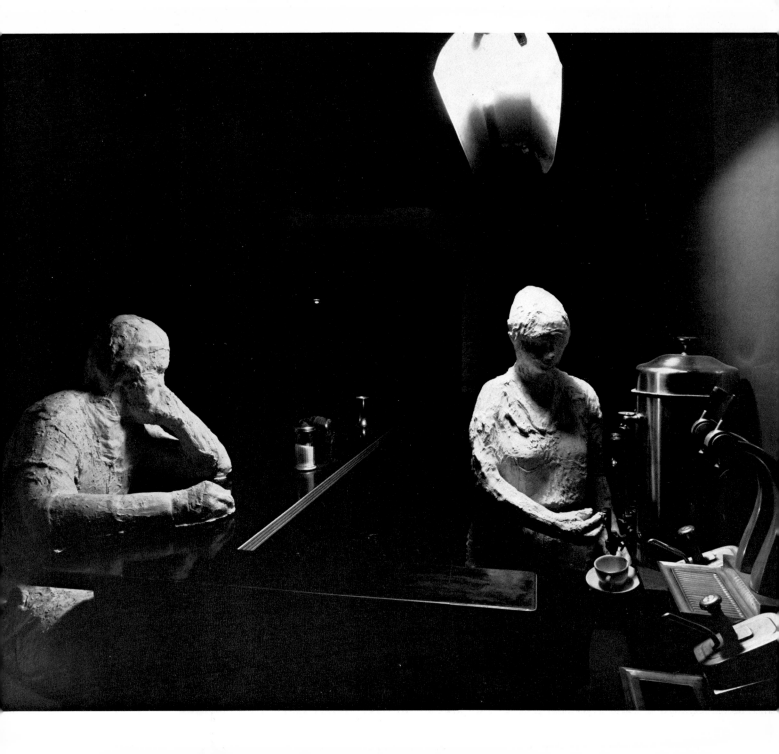

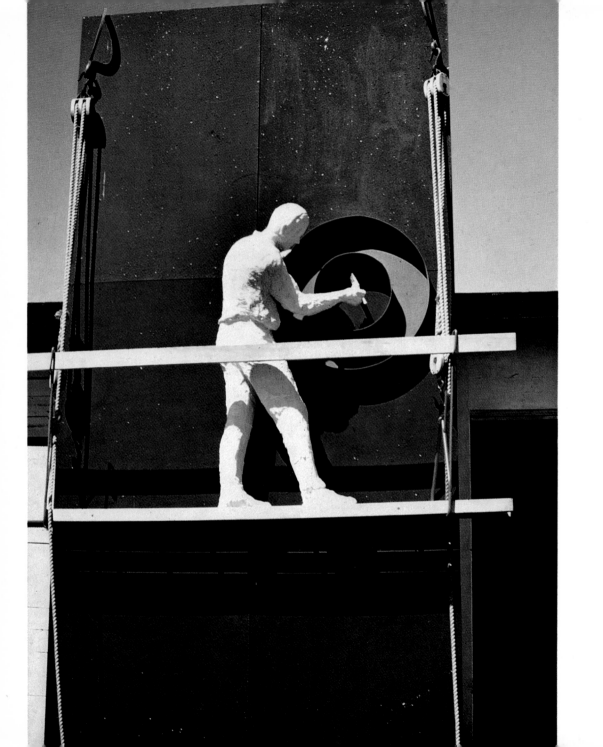

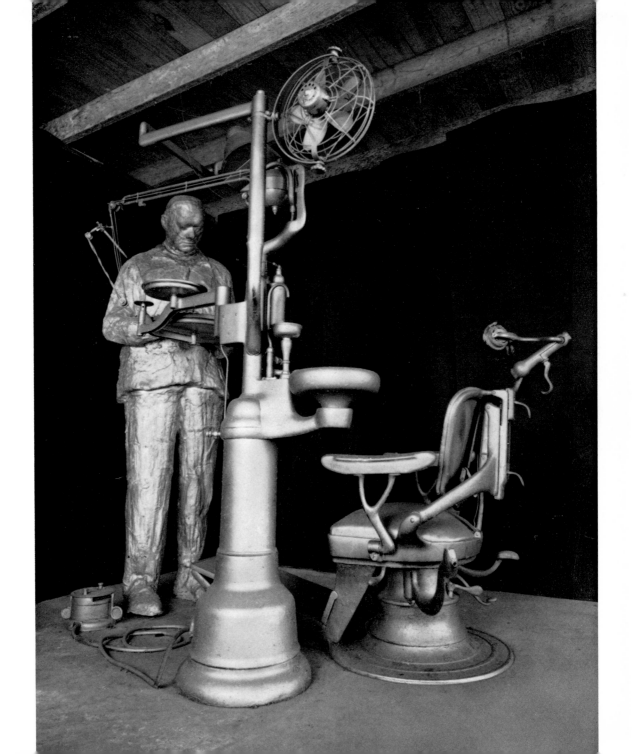

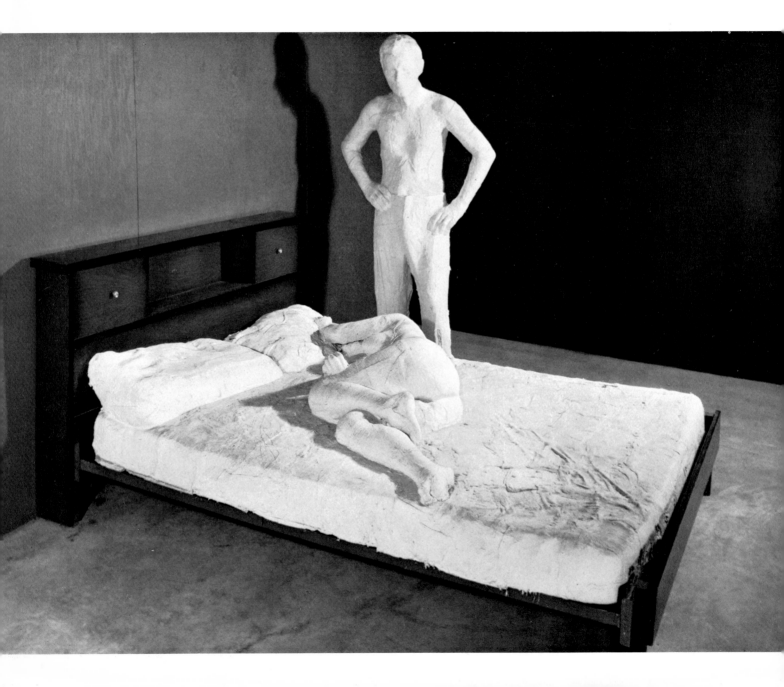

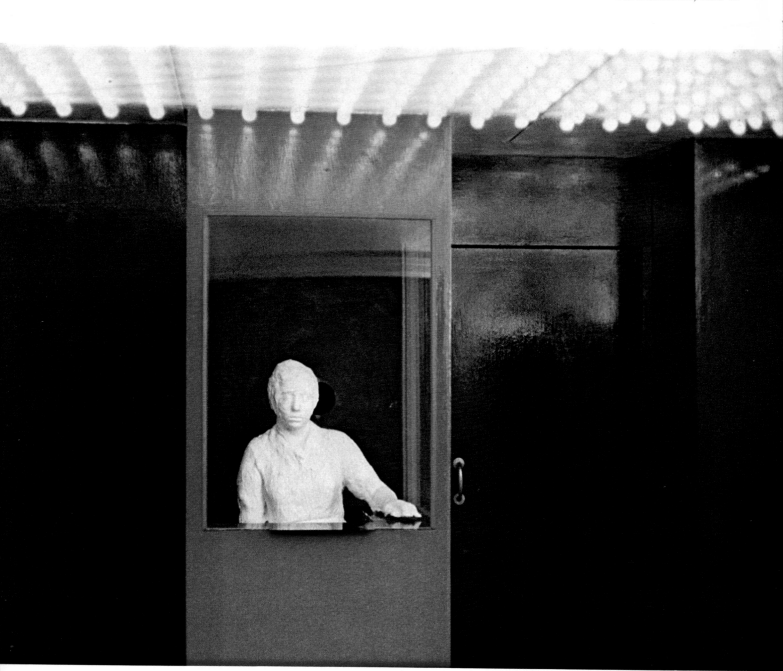

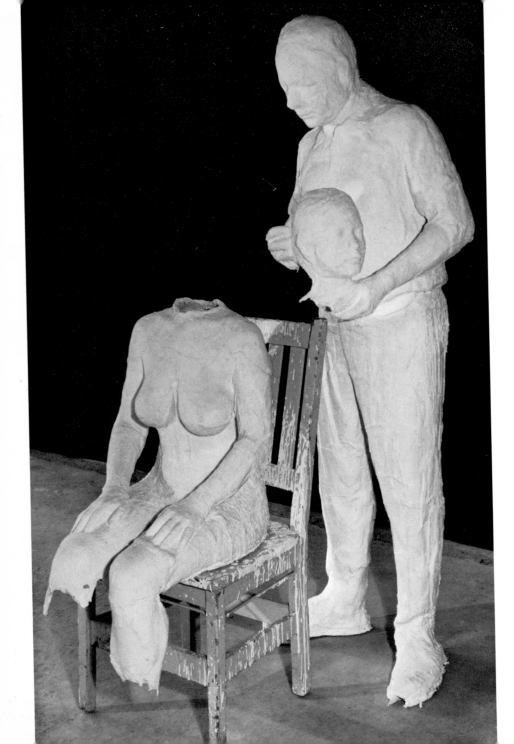

Self-Portrait: Artist, Head, and Body, 1968

Execution, 1967

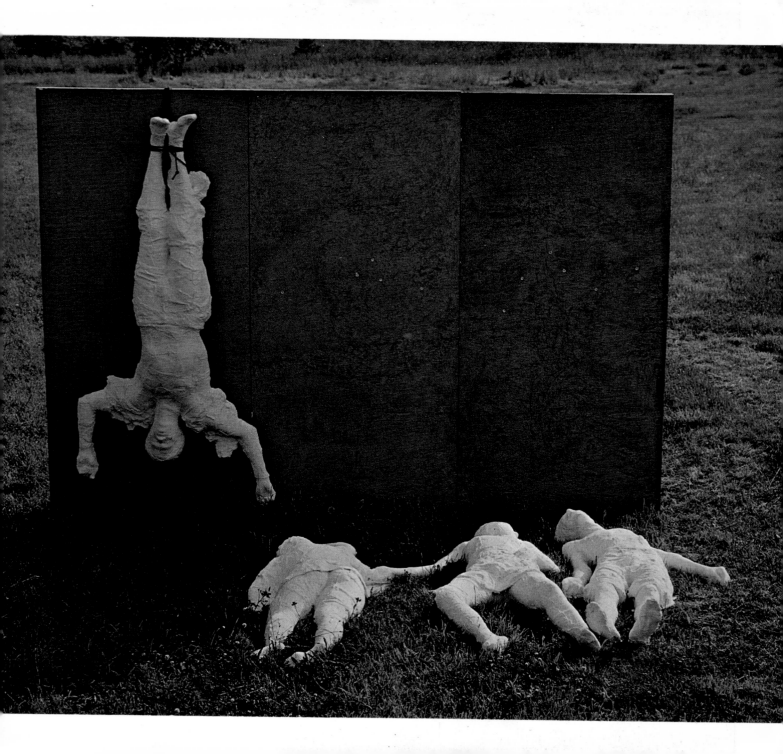

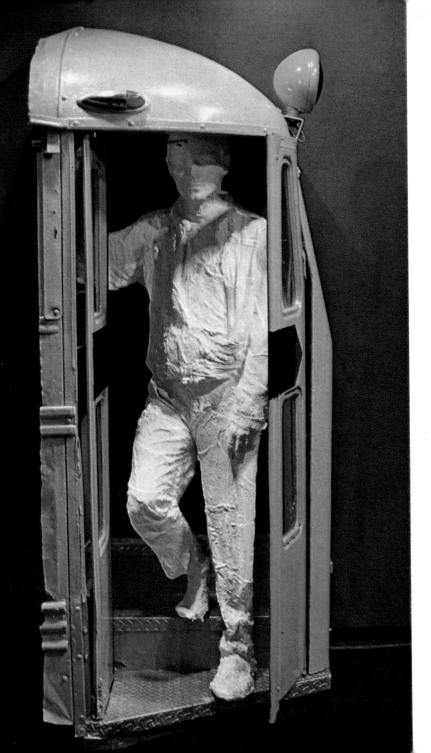

Man Leaving a Bus, 1967

The Restaurant Window, 1967

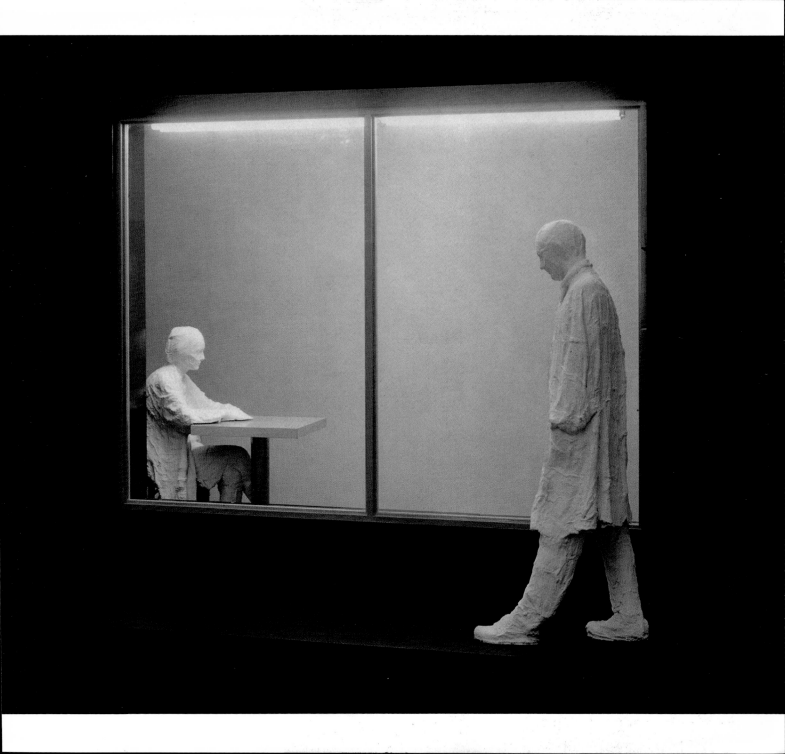

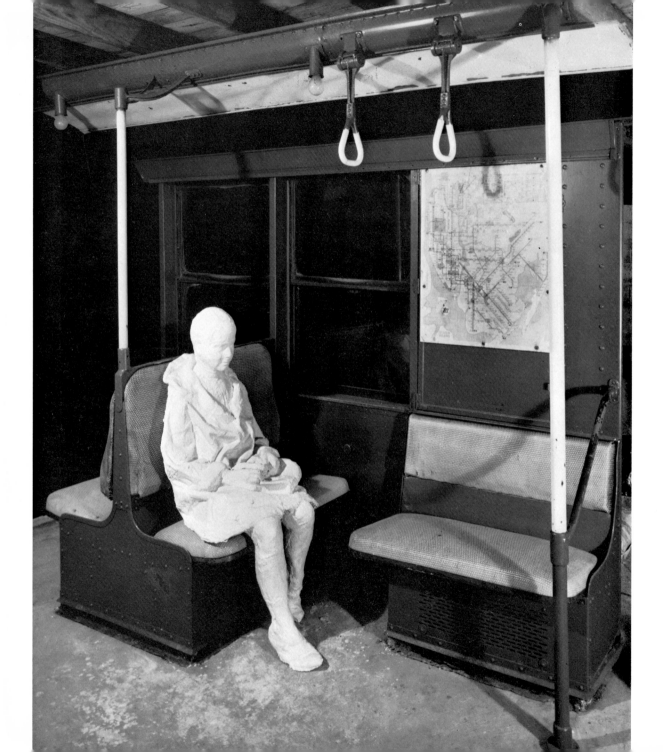

The Subway, 1968

Girl
Sitting Against a Wall,
1968

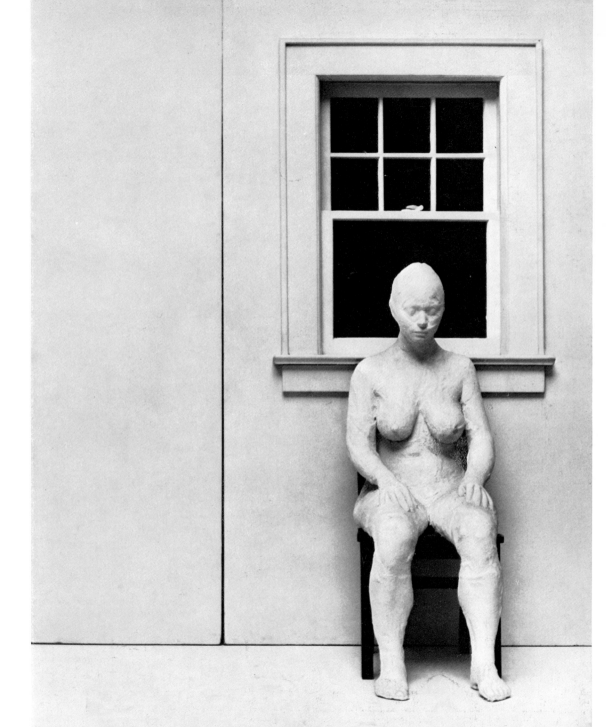

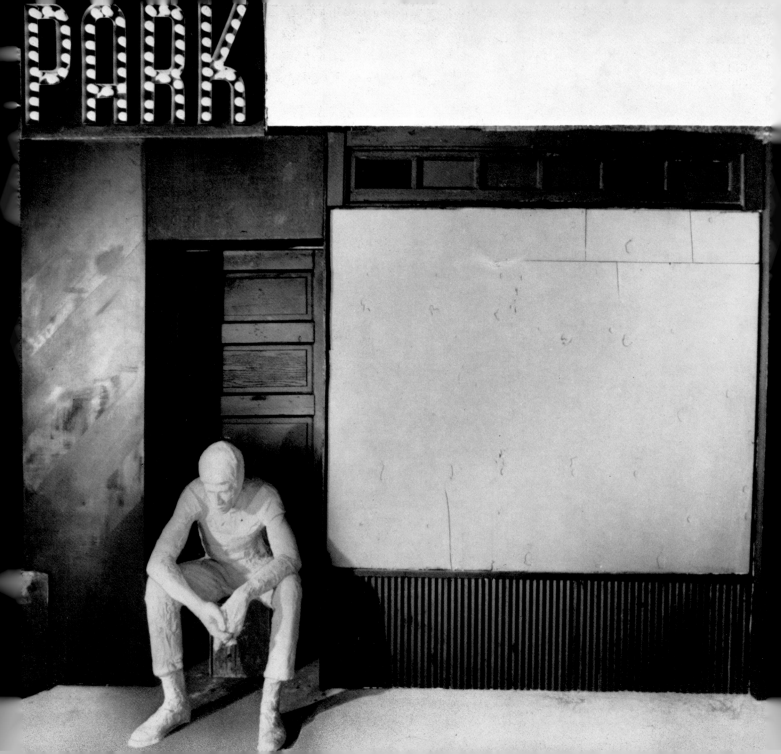

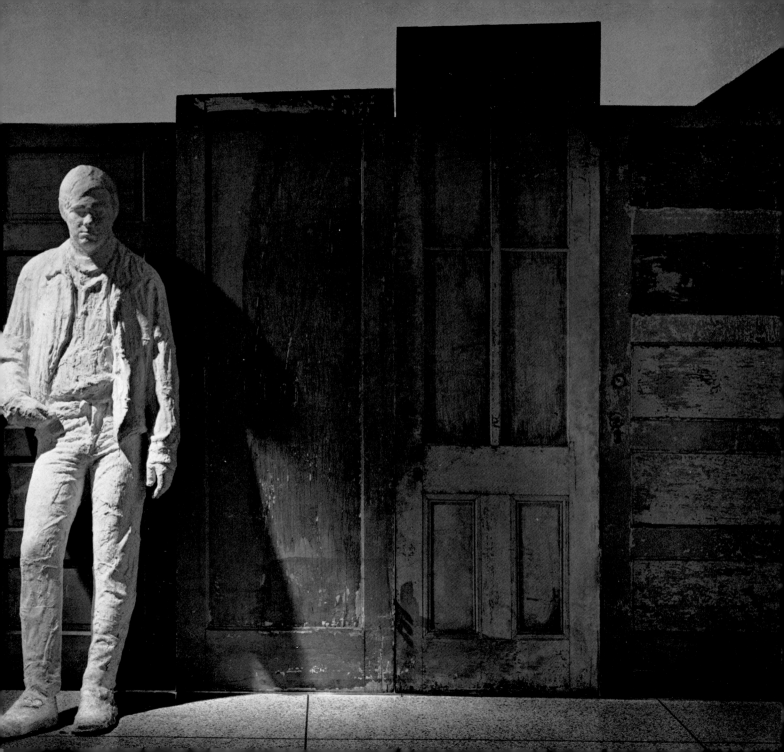

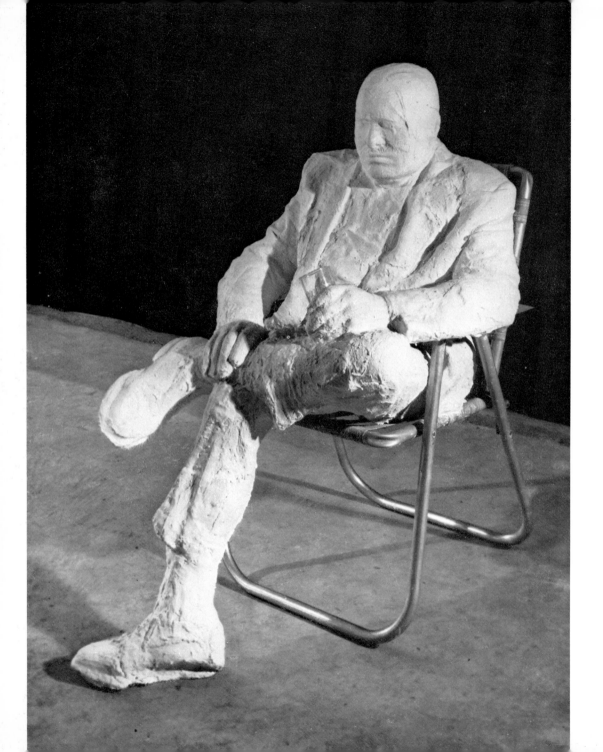

Man in a Chair, 1968

The Laundromat, 1966–67

74

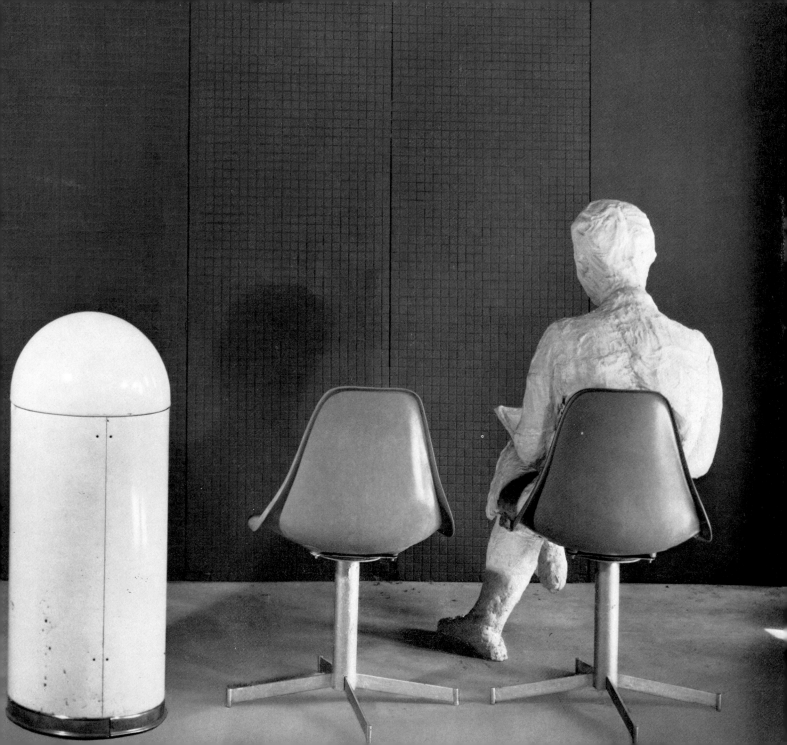

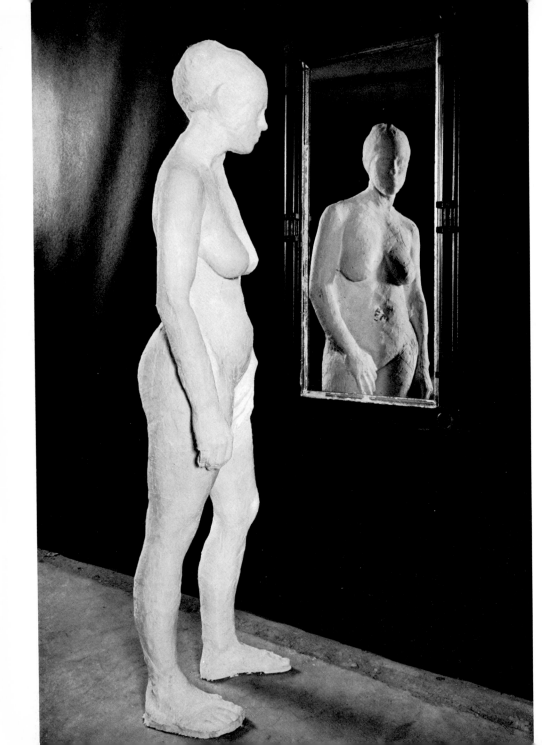

Girl
Looking into a Mirror,
1970

The Bowery, 1970

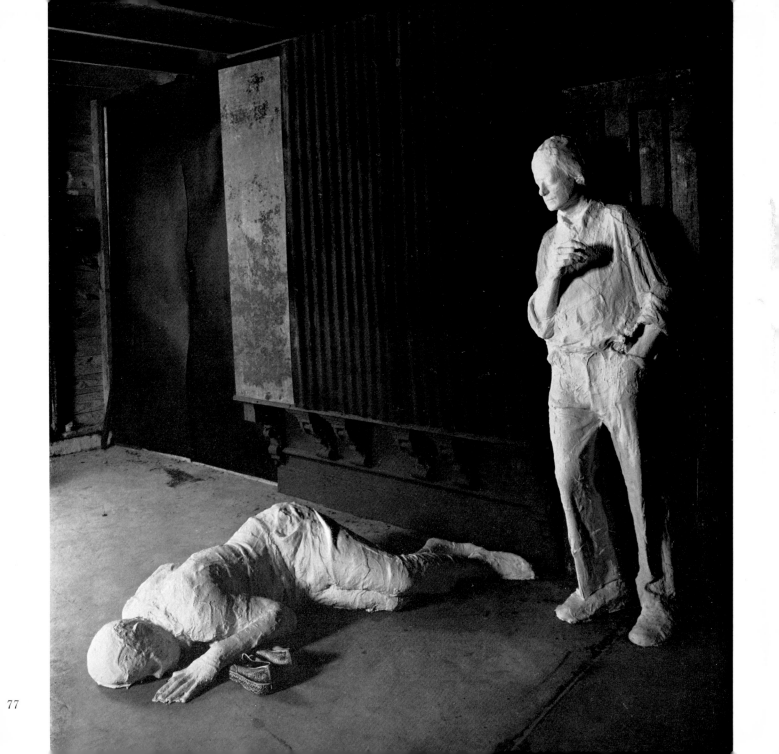

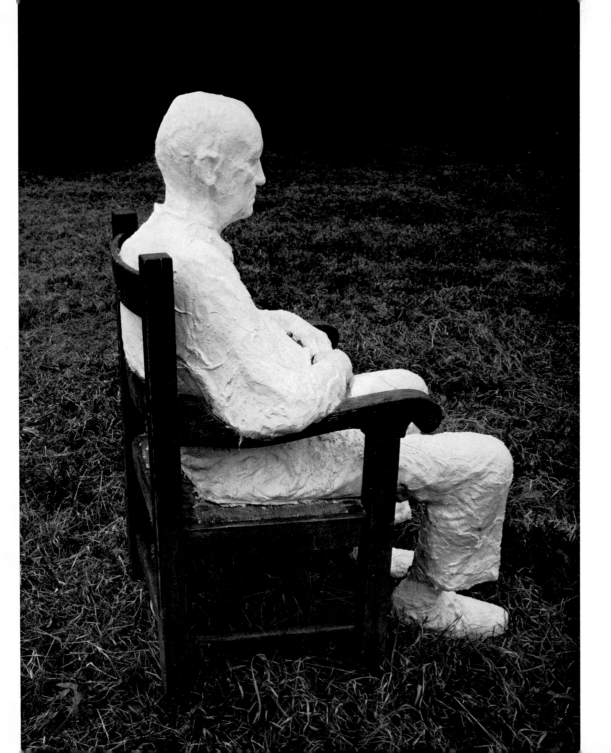

Man in a Chair
(Helmut von Erffa),
1969

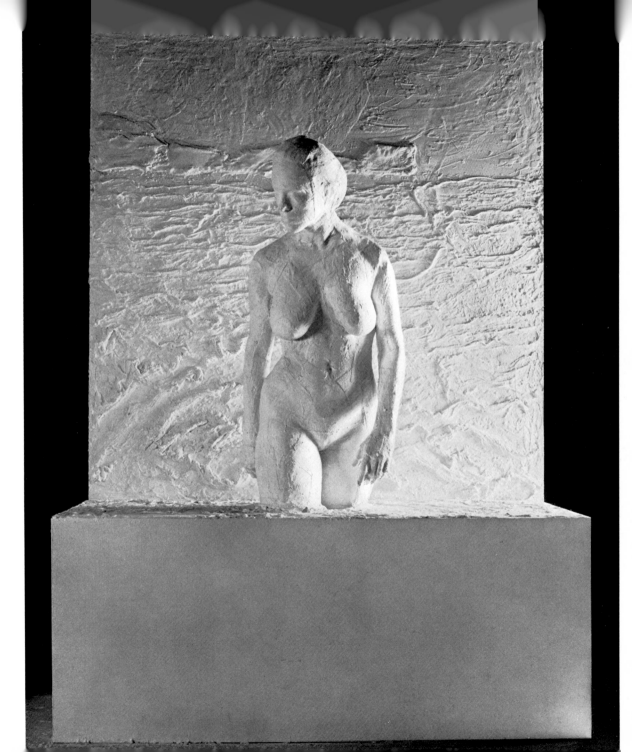

Girl
Walking out
of the Ocean,
1970

View of the Artist's Studio,
March, 1970

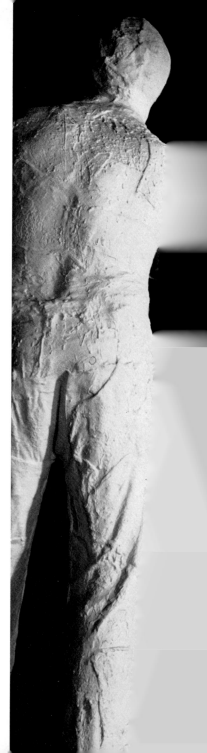

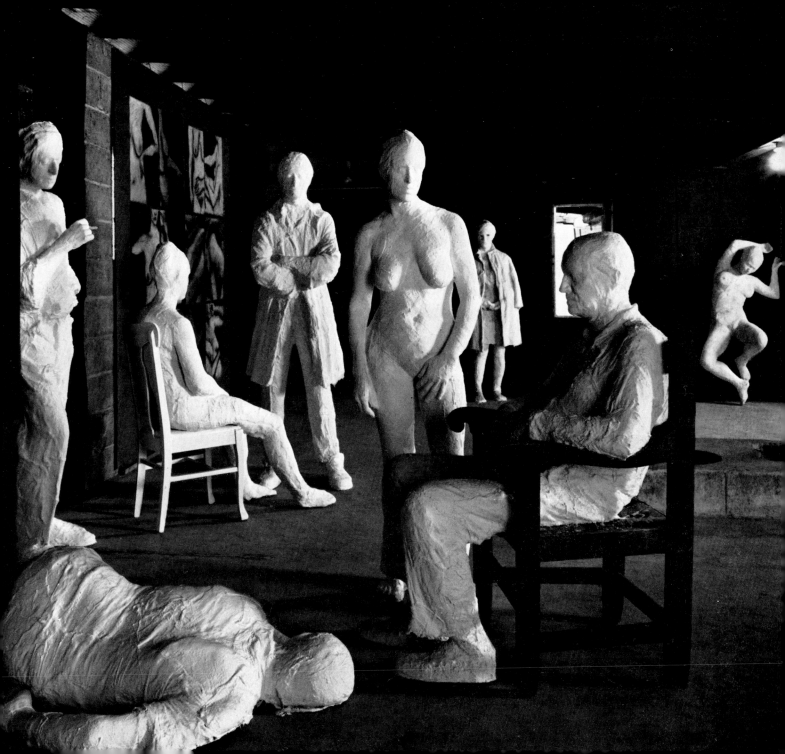

The Open Door, 1969

The Coffee Shop, 1969

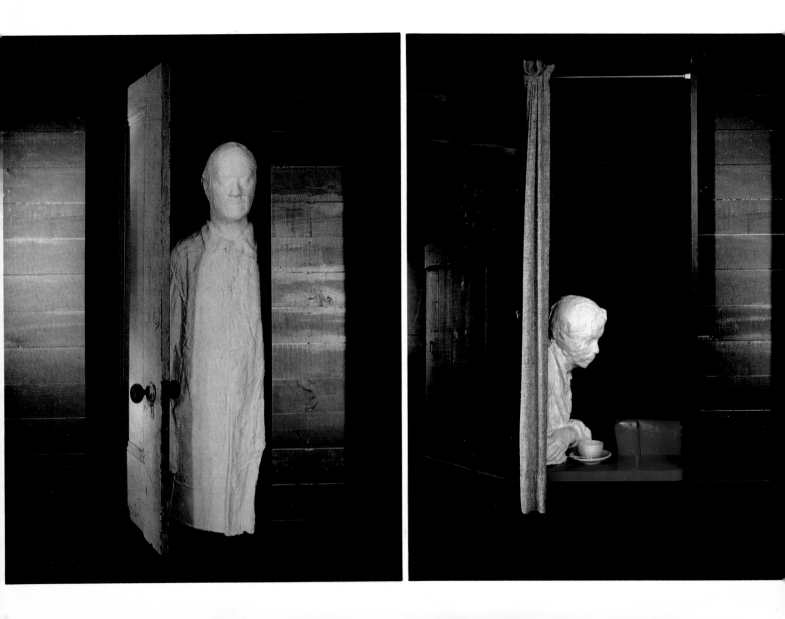

Woman
Looking Through a Window, 1969

Man in a Bar, 1969

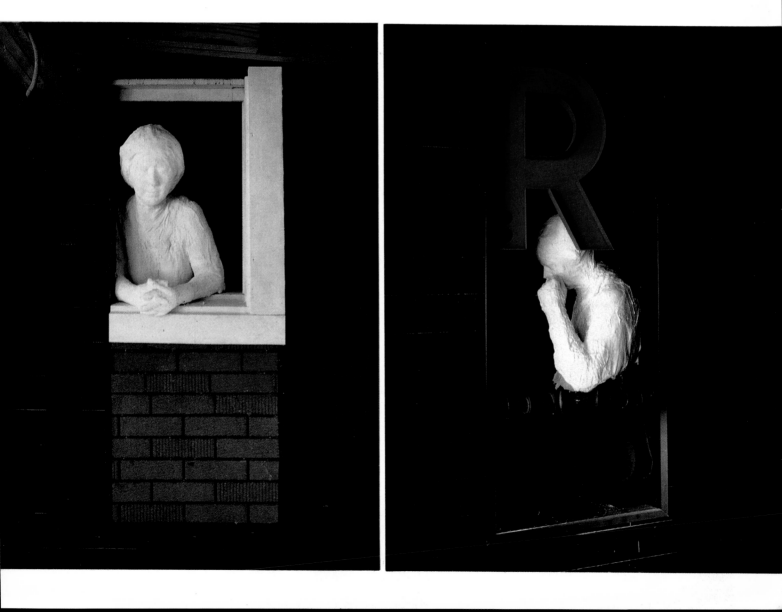

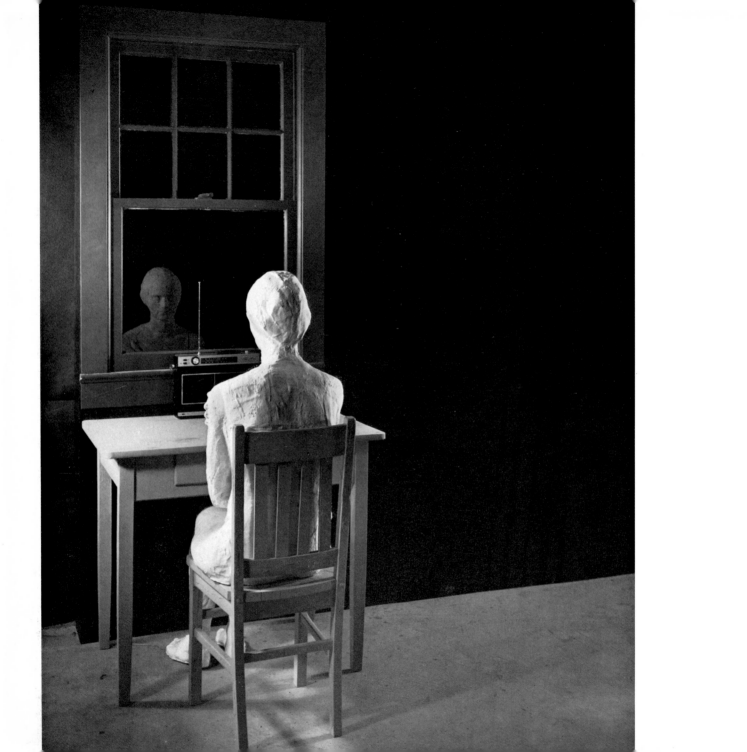

Alice,
Listening to Her Poetry and Music,
1970

Times Square at Night, 1970

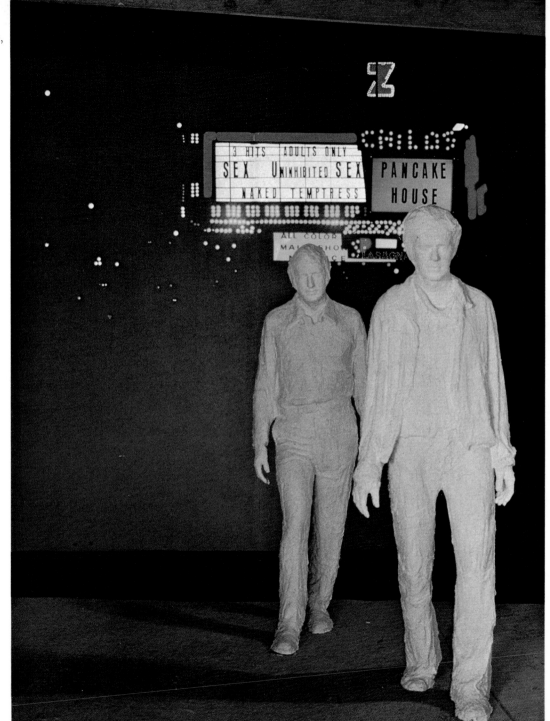

Page 86
85 The Aerial View, 1970

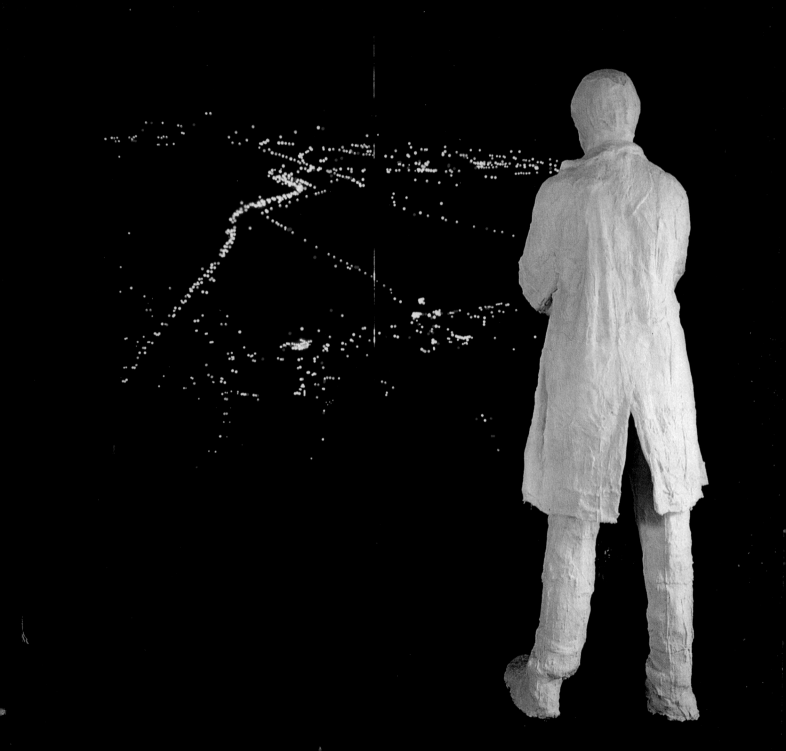

53 Ruth in the Kitchen, 1964–66
Plaster and wood, 50 × 72 × 60″. Von der
Heydt-Museum, Wuppertal

54 The Bus Station, 1965
Plaster, plastic, and wood, 96 × 48 × 24″.
Collection Mr. and Mrs. Howard Lipman,
New York

55 The Photobooth, 1966
Plaster, plastic, glass, metal, wood, and
lights, 72 × 73 × 29″. Collection Dr. and Mrs.
Sidney Wax, Toronto

56 John Chamberlain Working, 1965–67
Plaster, metal, plastic, and aluminum paint,
69 × 66 × 56″. Collection William S. Rubin,
New York

57 Walking Man, 1966
Plaster, painted metal, and wood, 85 × 58 ×
54″. Collection Mr. and Mrs. Norman B.
Champ, Jr., St. Louis

58–59 The Costume Party, 1965
Acrylic on plaster, metal, wood, and mixed
media, 72 × 144 × 108″. Sidney Janis Gal-
lery, New York

60 The Legend of Lot, 1966
Plaster, 72 × 96 × 108″. Kaiser-Wilhelm-
Museum, Krefeld

61 The Diner, 1964–66
Plaster, wood, chrome, formica, and mason-
ite, 102 × 108 × 87″. Walker Art Center,
Minneapolis

62 The Billboard, 1966
Plaster, wood, metal, and rope, 189 × 117 ×
20″. Private collection

63 The Dentist, 1966–67
Plaster, metal, plastic, rubber, glass, dental
cement, and aluminum paint, 80¹/₂ × 55 ×
55″. Sidney Janis Gallery, New York

64 The Motel Room, 1967
Plaster and wood, 72 × 78 × 72″. Collection
Pierre Janlet, Brussels

65 The Moviehouse, 1966–67
Plaster, wood, plastic, and lights, 102 × 148 ×
153″. Centre National d'Art Contemporain,
Paris

66 Self-Portrait: Artist, Head, and Body, 1968
Plaster and wood, 66 × 52 × 42″. Collection
Carter Burden, New York

67 Execution, 1967
Plaster, rope, metal, and wood, 96 × 152 ×
96″. Vancouver Art Gallery, Vancouver

68 Man Leaving a Bus, 1967
Plaster, painted metal, chrome, rubber, and
glass, 88¹/₂ × 59 × 55¹/₂″. The Harry N.
Abrams Family Collection, New York

69 The Restaurant Window, 1967
Plaster, plastic, metal, and wood, 96 × 138 ×
69″. Wallraf-Richartz-Museum, Cologne;
Ludwig Collection

70 The Subway, 1968
Plaster, metal, glass, rattan, electrical parts,
light bulbs, 90 × 114¹/₂ × 53″. Collection Mr.
and Mrs. Robert B. Mayer, Winnetka, Ill.

71 Girl Sitting Against a Wall, 1968
Plaster, wood, and glass, height of figure
48″. Staatsgalerie Stuttgart

72 The Parking Garage, 1968
Plaster, wood, metal, electrical parts, light
bulbs, 120 × 152 × 48″. Newark Museum,
New Jersey

73 Man Leaning Against a Wall of Doors, 1968
Plaster, wood, and metal, height of figure
c. 69″ Museum, Croton-on-Hudson (Gift of
the Geigy Chemical Corp.)

74 Man in a Chair, 1968
Plaster, plastic, aluminum, glass, 42 × 24 ×
42″. Galerie Onnasch, Cologne

75 The Laundromat, 1966–67
Plaster, metal, and plastic, 72 × 72 × 30″.
Sidney Janis Gallery, New York

76 Girl Looking into a Mirror, 1970
Plaster, wood, and mirror, 72 × 28 × 27″.
Collection Mr. and Mrs. Frederick Weis-
mann, Beverly Hills, Calif.

77 The Bowery, 1970
Plaster, wood, and metal, 96 × 96 × 72″. Sid-
ney Janis Gallery, New York

78 Man in a Chair (Helmut von Erffa), 1969
Plaster and wood, 50 × 29 × 36″. Sidney Janis
Gallery, New York

79 Girl Walking out of the Ocean, 1970
Plaster and wood, 84 × 60 × 28¹/₂″. Collection
Roger Stallaerts, Brussels

80–81 View of the Artist's Studio, March, 1970

82 (left) The Open Door, 1969
Plaster, wood, metal, 60 × 24 × 12″. Collec-
tion of the Artist

82 (right) The Coffee Shop, 1969
Plaster, cloth, wood, metal, plastic, 60 ×
24 × 12″. Collection Ivan Lechien, Brussels

83 (left) Woman Looking Through a Window,
1969
Plaster, wood, cloth, 60 × 24 × 12″. Collec-
tion Serge De Bloe, Brussels

83 (right) Man in a Bar, 1969
Plaster, wood, metal, cloth, 60 × 24 × 12″.
Collection Mr. and Mrs. E. A. Bergmann,
Chicago

84 Alice Listening to Her Poetry and Music,
1970
Plaster, wood, glass, and tape recorder, 96 ×
96 × 53″. Sidney Janis Gallery, New York

85 Times Square at Night, 1970
Plaster, wood, plastic, and electrical parts,
106 × 96 × 61″. Sidney Janis Gallery, New
York

86 The Aerial View, 1970
Plaster, wood, plastic, incandescent and
fluorescent light, 96 × 104 × 48″. Sidney
Janis Gallery, New York

Biography

1924 Born November 26 in New York City.

1941 Study at Cooper Union School of Art and Architecture, New York City.

1941–1946 Study at Rutgers University, North Brunswick, New Jersey.

1947 Study at Pratt Institute of Design, Brooklyn.

1950 B.S. in Art Education at New York University. Begins to run a chicken farm in South Brunswick to earn his living. First paintings.

Meets Allan Kaprow, who organizes Segal's first exhibition of paintings for the students of Hans Hofmann. At this time, he is strongly influenced by Hofmann's principles. According to Robert Pincus-Witten, Segal's paintings show an innate sense of color, a balanced composition, a spontaneous kind of drawing, and a natural talent for the representation of the human figure.

His models are Matisse and Bonnard.

1956 First one-man show at the Hansa Gallery, skeptical reaction of critics and the public.

Participation in the development of Happenings, some of which take place on his farm.

1957–1963 Teacher in the New Jersey High Schools.

1958 Discovers that sculpture is more akin to his talents than painting.

Experiments with lifesize figures fabricated from wire, plaster, and burlap, which are neither portraits nor casts.

1960 Exhibition in the newly-founded Green Gallery directed by Richard Bellamy. From now on, Segal shows sculptures as well as paintings.

1960/61 Gives up painting for good, though he continues to draw pastels. Transition from fictitious figure sulptures to plaster casts from identifiable models: figures with simple gestures and architectonic requisites or para-environments.

1962 In spring, Segal exhibits an environmental sculpture with plaster casts from friends and acquaintances which he slightly reworked and placed in ordinary situations and Readymade surroundings. Critics comment vigorously. Erroneously, his works are seen in connection with the then rising Pop Art.

Segal's way of sculptural expression is by now established. He is searching for new details and new technical methods. Literature explaining his oeuvre is increasing.

1963 M.A. in Fine Arts at Rutgers University, North Brunswick.

1965 Composed new environments in which the meticulously represented surroundings accentuate the fundamental differences between the results of his imagination and real objects.

1969 His work tends to show a more markedly autobiographical note.

Instead of composing isolated group situations, he combines these into a series of house fronts where each single scene is subordinated to an overall impression.

1970 Honorary Ph.D. in Fine Arts at Rutgers University.

1971/72 First large-scale exhibition of work in European museums (see list of exhibitions).

Bibliography

Interviews and Texts by George Segal

"Ma première sculpture date de 1958 ...," in: *Segal* [exhibition catalogue], Paris, Galerie Ileana Sonnabend, 1963. Reprinted in: *Amerikansk Pop-konst* [exhibition catalogue], Stockholm, Moderna Museet, 1964, p. 74; and in: Rolf-Gunter Dienst. *Pop-Art. Eine kritische Information.* Wiesbaden, Limes Verlag, 1965, pp. 155–36.

"Pop Art: A Dialogue Between Sidney Tillim and George Segal," *Eastern Arts Quarterly* (Kutztown, Pa.), Sept./Oct. 1963, pp. 10–19. Partially reprinted in: Gert Kreytenberg. *George Segal: Ruth in Her Kitchen.* Stuttgart, Reclam, 1970, pp. 11, 13, 18, 20.

Geldzahler, Henry. "An Interview with George Segal," *Artforum* (Los Angeles), vol. III, no. 2, Nov., 1964, pp. 26–29.

Métamorphoses: L'Ecole de New York. Film by Jean Antoine. Belgian Television, 1965.

"Métamorphoses: L'Ecole de New York. Un film de Jean Antoine," *Quadrum* (Brussels), vol. XVIII, 1965, pp. 161–64.

Geldzahler, Henry. "Interview with George Segal," *Quadrum* (Brussels), vol. XIX, 1965, pp. 118–26, ill. Partially reprinted in: Gert Kreytenberg, *op. cit.*, pp. 9, 14, 20.

"George Segal on the New York School," *Albright-Knox Art Gallery Notes* (Buffalo, N.Y.), vol. XXIX, no. 2, Autumn, 1966, pp. 22–23, ill.

"Segal s'explique," *Aujourd'hui* (Boulogne), vol. 10, Jan., 1967, pp. 128–31, ill.

"Sensibility of the Sixties," *Art in America* (New York), vol. 55, Jan./Feb., 1967, p. 55.

Lecture by George Segal at the Albright-Knox Art Gallery, Buffalo, N.Y., Feb. 27, 1967.

Commentary to his pictures, in: *Dine, Oldenburg, Segal: Painting, Sculpture* [exhibition catalogue]. Toronto, Art Gallery of Ontario, and Buffalo, Albright-Knox Art Gallery, 1967, pp. 57–59, ill. 61–70.

"Jackson Pollock: An Artists' Symposium—Part II," *Art News* (New York), vol. 66, May, 1967, pp. 29, 69–70.

"The Sense of 'Why Not?': George Segal on His Art," *Studio International* (London), vol. 174, Oct., 1967, pp. 146–49, ill. Introductory statement by William C. Lipke.—Partially reprinted in: *IX Bienal São Paulo* [exhibition catalogue], 1967, pp. 102–3; *New Figuration USA. 1963–68* [exhibition catalogue], Washington, D.C., Smithsonian Institution, 1968; *George Segal* [exhibition catalogue], Zurich, Kunsthaus, and Darmstadt, Hessisches Landesmuseum, 1972, pp. 17–22; cited in: Gert Kreytenberg, *op. cit.*, pp. 8, 9, 11, 15, 18.

"Conversations with George Segal," ed. by Don Cyr, *School Arts* (Worcester, Mass.), vol. 67, Nov., 1967, pp. 30–31.

"Interview mit George Segal," in exhibition catalogue of Galerie Onnasch, Cologne, 1971.

Catoir, Barbara. "Interview mit George Segal," *Das Kunstwerk* (Stuttgart), vol. XXIV, no. 3, May, 1971, pp. 3–8, ill.

Tuchman, Phyllis. "Interview with George Segal," *Art in America* (New York), May/June, 1972, pp. 73–81.

Monograph Publications

Books

Calvesi, Maurizio. "Segal e Oldenburg," in: *Le Due Avanguardie.* Milan, Lerici, 1966.

Kreytenberg, Gert. *George Segal: Ruth in Her Kitchen.* Stuttgart, Reclam, 1970.

van der Marck, Jan. *George Segal.* New York, Harry N. Abrams, in preparation.

Magazines and Exhibition Catalogues

Art in America (New York), June, 1965, p. 53: "New Interior Decorators."

Art News (New York), Oct., 1970, p. 70: "Pace Graphics Gallery, New York; Exhibition."

Arts Canada (Toronto), vol. 24, suppl. 1, Apr., 1967: "Controversial Codpiece," ill.

Arts Magazine (New York), vol. 31, May, 1957, p. 50: "Exhibition of Oils and Pastels at Hansa Gallery."

Arts Magazine (New York), vol. 43, Nov., 1968, p. 57: "Exhibition at Janis Gallery," ill.

Arts Magazine (New York), vol. 44, May, 1970, p. 56: "Segal at Sidney Janis," ill.

Ashberg, John. "George Segal" [exhibition at Hansa Gallery], *Art News* (New York), vol. 56, Feb., 1958, p. 11.

Atirnomis (Rita Simon). "George Segal at Janis," *Arts Magazine* (New York), Apr., 1971.

Beck, Julian H. "George Segal" [exhibition at Green Gallery], *Art News* (New York), vol. 59, Nov., 1960, p. 14.

Borgeaud, Bernard. "Arts – Segal: l'accablante banalité du quotidien," *Pariscope* (Paris), March 26/Apr. 1, 1969.

Calas, Elena. "George Segal and His Earthbound Ghost," *Colóquio Artes* (Lisbon), vol. 13, no. 3, June, 1971, pp. 34–37, ill.

Campbell, Lawrence. "George Segal" [exhibition at Sidney Janis Gallery], *Art News* (New York), vol. 66, May, 1967, pp. 17, 56.

Campbell, Lawrence. "George Segal" [exhibition at Sidney Janis Gallery], *Art News* (New York), vol. 69, Summer, 1970, p. 68.

Courtois, Michel. "George Segal," in: *Segal* [exhibition catalogue], Paris, Galerie Ileana Sonnabend, 1963.

Friedman, Martin. "Mallary, Segal, Agostini. The Exaltation of the Prosaic," *Art International* (Lugano), vol. VII, no. 8, Nov., 1963, pp. 50–71.

Geldzahler, Henry. "George Segal," in: *Recent American Sculpture* [exhibition catalogue], New York, Jewish Museum, 1964, pp. 25–26, ill. p. 27. Reprinted in: *Quadrum* (Brussels), vol. XIX, 1965, pp. 115–16.

Glueck, Grace. "George Segal" [exhibition at Sidney Janis Gallery], *Art in America* (New York), vol. 58, May, 1970, p. 32, ill. 58.

Guest, Barbara. "George Segal" [exhibition at Hansa Gallery], *Arts Magazine* (New York), vol. 30, Mar., 1956, p. 60.

Hakanson, Bjorn. "George Segals Skulpturer," *Konstrevy* (Stockholm), vol. LXII, no. 5–6, 1966, pp. 232–34.

Hoene, Anne. "Exhibition at Sidney Janis Gallery," *Arts Magazine* (New York), vol. 40, Dec., 1965, p. 56, ill.

Johnson, Ellen H. "The Sculpture of George Segal," *Art International* (Lugano), vol. VIII, no. 2, Mar., 1964, pp. 46–49.

Johnston, Jill. "George Segal" [exhibition at Green Gallery], *Art News* (New York), vol. 61, May, 1962, p. 16, ill.

Johnston, Jill. "George Segal" [exhibition at Sidney Janis Gallery], *Arts Canada* (Toronto), vol. 24, suppl. 8, June/July, 1967.

Judd, Don. "George Segal" [exhibition at Green Gallery], *Arts Magazine* (New York), vol. 36, Sept., 1962, p. 55.

Kaprow, Allan. "Segal's Vital Mummies," *Art News* (New York), vol. 62, Feb., 1964, pp. 30–33, 65, ill.

Kennedy, R.C. "George Segal at the Galerie Darthea Speyer," *Art and Artists* (London), vol. 4, no. 3, June, 1969, pp. 20–21.

van der Marck, Jan. "George Segal," in: *Eight Sculptors: The Ambiguous Image* [exhibition catalogue], Minneapolis, Walker Art Center, 1966, pp. 26, 28, ills. 27, 29.

van der Marck, Jan. Preface and introduction in: *George Segal: 12 Human Situations* [exhibition catalogue], Chicago, Museum of Contemporary Art, 1968.

van der Marck, Jan. Preface in: *George Segal* [exhibition catalogue], Zurich, Kunsthaus, and Darmstadt, Hessisches Landesmuseum, 1972, pp. 6–16.

Melville, Robert. "Exhibition at Sidney Janis Gallery, New York," *Architectural Review* (London), vol. 138, July, 1965, p. 57, ill.

Perreault, John. "Plaster Caste: George Segal's Plaster People at Janis," *Art News* (New York), vol. 67, November, 1968, pp. 54–55, 75–76, ill.

Pincus-Witten, Robert. "George Segal," in: *Dine, Oldenburg, Segal: Painting, Sculpture* [exhibition catalogue], Toronto, Art Gallery of Ontario, and Buffalo, Albright-Knox Art Gallery, 1967, pp. 57–59, ills. 61–70. Reprinted in: *Art and Artists* (London), vol. II, no. 10, Jan., 1968, pp. 38–41.

Pincus-Witten, Robert. "George Segal as Realist," *Artforum* (Los Angeles), vol. V, no. 10, Summer, 1967, pp. 84–87.

Rauh, Emily S. "George Segal," in: *7 for '67* [exhibition catalogue], St. Louis, City Art Museum, 1967.

Russel, P. "Dine, Oldenburg, Segal: Painting, Sculpture, Art Gallery of Ontario," *Arts Canada* (Toronto), vol. 24, suppl. 3, Feb., 1967, ill.

Schuyler, James. "George Segal" [exhibition at Hansa Gallery], *Art News* (New York), vol. 57, Feb., 1959, p. 16.

Sorin, Raphael. "Le Silence de George Segal," *La Quinzaine Littéraire*, Apr., 1969, p. 15.

Swenson, Gene R. "Four Environments," *Art News* (New York), vol. 62, Feb., 1964, p. 8.

Tillim, Sidney. "George Segal" [exhibition at Green Gallery], *Arts Magazine* (New York), vol. 35, Dec., 1960, p. 54.

Tillim, Sidney. "George Segal" [exhibition at Green Gallery], *Arts Magazine* (New York), vol. 37, Mar., 1963, p. 62.

Time (New York), May 11, 1970, p. 72: "Ghost Maker."

Tuchman, Phyllis. "George Segal," *Art International* (Lugano), vol. XII, Sept., 1968, pp. 50–53, ill.

Tuchman, Phyllis. "George Segal," *Arts Magazine* (New York), vol. 43, no. 2, Nov., 1968, p. 57.

Tutten, Fred. "Exhibition at Sidney Janis Gallery," *Arts Magazine* (New York), vol. 41, Apr., 1967, p. 56, ill.

Tyler, Parker. "George Segal" [exhibition at Hansa Gallery], *Art News* (New York), vol. 55, Mar., 1956, p. 58.

Tyler, Parker. "George Segal" [exhibition at Hansa Gallery], *Art News* (New York), vol. 56, May, 1957, p. 12, ill.

The WMFT Guide (Chicago), Apr., 1968, first and last page: "Artist of the Month."

General Publications

Books

Amaya, Mario. *Pop as Art. A Survey of the New Super Realism*. London, Studio Vista, 1965, pp. 46, 97–98, ill. p. 99. Under the title *Pop Art ... And After* published by Viking Press, New York, 1966.

Arnason, H.H. *History of Modern Art: Painting—Sculpture—Architecture*. New York, Harry N. Abrams, 1968, and London, Thames and Hudson, 1969, pp. 571, 574, 581, 598ff., 600, 625, ill. 1057, col. pl. 259.

Barilli, Renato. "La scultura del novecento II," in: *Capolavori della Scultura*, no. 12. Milan, Fratelli Fabbri, p. 15, col. pl. LVII.

Battcock, Gregory, ed. *Minimal Art: A Critical Anthology*. New York, E.P. Dutton, 1968, pp. 86, 130n, 293, 329n.

Becker, Jürgen, and Vostell, Wolf, eds. *Happenings, Fluxus, Pop Art, Nouveau Réalisme*. Reinbek, Rowohlt, 1965, pp. 88, 96, 185, 186, ill. 41.

Boatto, Alberto. *Pop Art in U.S.A.* Milan, Lerici, 1967.

Bott, Gerhard, and Adriani, Götz, eds. *Bildnerische Ausdruckformen 1960–1970. Sammlung Karl Ströher im Hessischen Landesmuseum Darmstadt*. Catalogue no. 4 of Hessisches Landesmuseum, 1970, p. 12, 354–61, ills. 359, 361.

Burnham, Jack. *Beyond Modern Sculpture. The Effects of Science and Technology on the Sculpture of this Century*. New York, George Braziller, 1967, pp. 527–28.

Calas, Nicolas. *Art in the Age of Risk*. Introduction by Gregory Battcock: *Why Not Pop Art?* New York, E.P. Dutton, 1968, p. 45.

Dienst, Rolf-Gunter. *Pop-Art. Eine kritische Information*. Wiesbaden, Limes Verlag, 1965, pp. 46–47, 135–36, ill.

Dienst, Rolf-Gunter. *Positionen. Malerische Malerei – Plastische Plastik*. Cologne, M. DuMont Schauberg, 1968, p. 66.

Gassiot-Talabot, Gérald. "George Segal," in: *Nouveau dictionnaire de la sculpture moderne*, ed. by Robert Maillard. Paris, Fernand Hazan, 1970, p. 279, ill.

Geldzahler, Henry. *New York Painting and Sculpture: 1940–1970*. New York, The Metropolitan Museum of Art, and E.P. Dutton, 1970. pp. 31, 32, 448, 478.

Goodrich, Lloyd. *Three Centuries of American Art*. New York, Frederick A. Praeger, 1966.

Grohmann, Will, ed. *Kunst unserer Zeit*. Colo-

gne, M. DuMont Schauberg, 1966, pp. 32–33, 45, ill. 220.

Hansen, Alfred E. *A Primer of Happenings and Time/Space Art.* New York, Something Else Press, 1965.

Huyghe, René, and Rudel, Jean. *L'Art et le monde moderne,* vol. 2. Paris, Librairie Larousse, 1970, pp. 233, 383, 384, ill. 1293.

Kaprow, Allan. *Assemblage, Environments & Happenings.* New York, Harry N. Abrams, 1966, ills. 27, 66, 86, 87, 98.

Kultermann, Udo. *Neue Dimensionen der Plastik.* Tübingen, Ernst Wasmuth, 1967, pp. 14, 20, 24, ills. 8, 10.

Lippard, Lucy R. *Pop Art.* London, Thames and Hudson, and New York, Frederick A. Praeger, 1966, pp. 74, 83, 101, 102, ill. 78.

Lucie-Smith, Edward. *Kunstrichtungen seit 1945.* Vienna–Munich–Zurich, Fritz Molden, 1970, pp. 158, 251, ill. 218.

Lützeler, Heinrich. "Kunst und Literatur um 1960. Drei Stücke aus der Sammlung Ludwig—George Segal: Das Restaurant-Fenster. 1967," in: *Festschrift für Gert von der Osten.* Cologne, M. DuMont Schauberg, 1970, pp. 243–46, 255–56, ill. 1.

Ohff, Heinz. *Pop und die Folgen.* Düsseldorf, Droste, 1968, pp. 28 ff., 56, 78, 92, 162, 170, ills. 26, 133.

von der Osten, Gert, and Keller, Horst, eds. *Kunst der sechziger Jahre. Sammlung Ludwig im Wallraf-Richartz-Museum, Köln.* Cologne, 3rd ed., 1969, pp. 119–21, ill.

Pellegrini, Aldo. *New Tendencies in Art.* New York, Crown Publishing Company, 1966.

Rose, Barbara. *American Art Since 1900: A Critical History.* New York–Washington, Frederick A. Praeger, 1967.

Rosenberg, Harold. *The Anxious Object. Art Today and Its Audience.* New York, Horizon Press, 1966, pp. 73–74, ill. p. 68.

Russell, John, and Gablik, Suzi. *Pop Art Redefined.* London, Thames and Hudson, 1969, pp. 16, 22, 38, 39, 53, ills. 9, 35, 94.

Solomon, Alan R., and Mulas, Ugo. *New York: The New Art Scene.* New York, Holt, Rinehart and Winston, 1967, p. 270, ills. pp. 271–89.

Weber, Jürgen. *Pop-Art, Happenings und neue Realisten.* Munich, Heinz Moos, 1970, p. 84, ills. 104–9.

Magazines and Exhibition Catalogues

Alloway, Lawrence. "Art as Likeness," *Arts Magazine* (New York), vol. 41, May, 1967, pp. 34–40.

Amaya, Mario. "The New Super Realism," *Sculpture International* (London), vol. 1, Jan., 1966, p. 19.

Art International (Lugano), vol. XII/2, Feb. 20, 1969: "New York Letter."

Arts Canada (Toronto), June, 1968: "Four Major Exhibitions This Spring."

Arts Magazine (New York), June, 1969: "Seven at Janis."

Ashton, Dore. "Unconventional Techniques in Sculpture," *Studio International* (London), vol. 169, June, 1965, p. 23.

Ashton, Dore. "Life and Movement Without Recession. New York Commentary," *Studio International* (London), vol. 170, Dec., 1965, p. 252.

Ashton, Dore. "New York Commentary," *Studio International* (London), vol. 173, June, 1967, p. 319, ill.

Ashton, Dore. "Protest and Hope at the New York School," *Studio International* (London), vol. 174, Dec., 1967, p. 278, ill.

Baker, Kenneth. "New York. Exhibition at Sidney Janis Gallery," *Artforum* (Los Angeles), June, 1971, p. 81, ill.

Bannard, Darby "Present-Day Art and Ready-Made Styles," *Artforum* (Los Angeles), vol. 5, Dec., 1966, pp. 30–35.

Bannard, Darby. "Notes on an Auction," *Artforum* (Los Angeles), vol. 9, Sept., 1970, p. 63, ill.

Bayl, F. "Wohlbefinden und Mysterium: Ausstellungen in Paris," *Das Kunstwerk* (Baden-Baden), vol. XVII, Dec., 1963, p. 25.

Benedikt, Michael. "New York Letter," *Art International* (Lugano), vol. IX, no. 9–10, Dec., 1965, pp. 36, 41, ill.

Benedikt, Michael. "New York; Notes on Whit-ney Annual 1966," *Art International* (Lugano), vol. XI, no. 2, Feb., 1967, p. 61.

Biemel, Walter. "Pop-Art und Lebenswelt. Die zwischenmenschlichen Beziehungen," *Aachener Kunstblätter* (Düsseldorf), vol. 40, 1971, pp. 212–14, ills. 15, 16, cover.

Billeter, Erika. "'Pop' im Examen (Atelier-besuche bei fünf New Yorker Künstlern)," *Speculum Artis* (Zurich), vol. 17, Sept., 1965, pp. 26, 50–57, ill.

von Bonin, Wibke. "Notizen zur Plastik der jüngeren Generation," in: *Amerikanische Plastik, USA 20. Jahrhundert* [exhibition catalogue], Berlin, Kunstverein, and Baden-Baden, Staatliche Kunsthalle, 1966, ill.

Clay, Jean. "Art...Should Change Man," *Studio International* (London), vol. 171, Mar., 1966, p. 119, ill.

Davis, Douglas M. "The New Eroticism," *Evergreen* (New York), vol. 12, no. 58, Sept., 1968, pp. 49–55.

Dypréau, Jean. "Van Pop-Art tot environment," in: *De metamorfose van het object* [exhibition catalogue]. Rotterdam, Museum Boymans–van Beuningen, 1971, p. 128, ill.

Eland, Ursula N. "Trends and Traditions: Recent Acquisitions," *Albright-Knox Art Gallery Notes* (Buffalo), vol. XXVII, no. 2, Spring, 1964, p. 12, col. pl.

Factor, Don. "Drawings, Feigen/Palmer," *Artforum* (Los Angeles), vol. 3, no. 9, June, 1965, p. 12.

Gablik, Suzi. "Meta–trompe–l'oeil," *Art News* (New York), vol. 64, Mar., 1965, p. 49, ill.

Goldsmith, Barbara. "How Henry Made 43 Artists Immortal," *New York* (New York), vol. 2, no. 41, Oct., 1969.

Gray, Cleve. "Remburgers and Hambrandts," *Art in America* (New York), vol. 51, Dec. 1963, p. 119, ill.

Gruen, John. "Galleries & Museums: Pleasantly Plastered," *New York* (New York), Apr./May, 1971.

D'Harnoncourt, A., and Hopps, W. "Etant donnés 1° la chute d'eau, 2° le gaz d'éclairage. Reflexions on a New Work by Marcel Duchamp," *Philadelphia Museum Bulletin,* vol. 64, Apr.–Sept., 1969, pp. 50–53, ill.

Henry, Gerrit. "New York Letter," *Art International* (Lugano), vol. XV, no. 6, June, 1971, p. 82.

Imdahl, Max. "Probleme der Pop Art," in: *Documenta 4* [exhibition catalogue], Kassel, Museum Fridericianum, 2nd ed., 1968, p. XV, ills. 268–71.

Irwin, David. "Pop Art and Surrealism," *Studio International* (London), vol. 171, May, 1966, p. 188, ill.

Kozloff, Max. "American Sculpture in Transition," *Arts Magazine* (New York), vol. 38, May, 1964, p. 22, ill.

Krauss, Rosalind. "New Erotic Art, Sidney Janis Gallery," *Artforum* (Los Angeles), vol. 5, no. 4, Dec., 1966, p. 59.

Kudielka, R. "Documenta 4: A Critical Review," *Studio International* (London), vol. 176, Sept., 1968, p. 77, ill.

Les Lettres Françaises (Paris), March 26/Apr. 2, 1969: "La Chronique de Jean Bouret: Sept Jours avec la peinture."

Lippard, Lucy R. "New York: Four Environments by New Realists. Sidney Janis," *Artforum* (Los Angeles), vol. 2, no. 9, Mar., 1964, pp. 8–10.

Maynard, Olga. "Conversations on the New Erotica," *After Dark*, Nov., 1969, pp. 30–37.

Mellow, James. "New York Letter," *Art International* (Lugano), vol. XIII, Feb., 1969, p. 45, ill.

Michelson, Annette. "Paris Letter," *Art International* (Lugano), vol. VII, no. 9, Dec., 1963, p. 55.

Miller, Donald. "The 1970 Pittsburgh International," *Art International* (Lugano), vol. XV, no. 2, Feb., 1971, p. 40.

New York (New York), May 11, 1970, p. 59: "Art: The Whole Message."

O'Doherty, Brian. "Urogenital Plumbing," *Art and Artists* (London), vol. I, no. 8, Nov., 1966, pp. 14–19.

Panorama 7, Feb., 1969, pp. 39–43: "Gezellig in Het Gips."

Peppiatt, M. "Paris Letter," *Art International* (Lugano), vol. XIII, May, 1969, p. 45, ill.

Perkins, Constance M. Preface in: *New Figuration USA. 1963–68.* [exhibition catalogue], Washington, D.C., Smithsonian Institution, 1968.

Pincus-Witten, Robert. "New York," *Artforum* (Los Angeles), vol. 4, no. 4, Dec., 1965, p. 5.

Restany, Pierre. "Le pop-art, un nouvel humanisme américain," *Aujourd'hui* (Boulogne), vol. 10, Jan., 1967, p. 121.

Robert, Colette. "Les expositions à New York," *Aujourd'hui* (Boulogne), vol. 8, Jan., 1964, p. 96, ill.

Rose, Barbara. "New York Letter," *Art International* (Lugano), vol. VIII, no. 3, Apr., 1964, pp. 52–56.

Rose, Barbara. "New York Letter," *Art International* (Lugano), vol. VIII, no. 10, Dec., 1964, pp. 47–51.

Rose, Barbara. "The Second Generation," *Artforum* (Los Angeles), vol. 4, no. 1, Sept., 1965, pp. 53–56.

Rose, Barbara, and Sandler, Irving. "Sensibility of the Sixties," *Art in America* (New York), vol. 55, Jan./Feb., 1967, p. 55.

Rosenblum, Robert. "Pop & Non-Pop: An Essay in Distinction," *Canadian Art*, no. 100, Jan., 1966, pp. 50–54.

Ross, F. T. "String and Rope," *Pictures on Exhibit*, Feb., 1970.

Rotzler, Willy. "Objekt und Objekt-Besessenheit in der Kunst von Dada bis Pop," *Du* (Zurich), vol. 29, Sept., 1969, p. 681, ill.

Seitz, William C. "Environment USA 1957–1967," in: *9 Bienal São Paulo – United States of America* [exhibition catalogue], São Paulo, Museu de Arte Moderna, 1967–68, pp. 63–65, ill. 37.

Solomon, Alan R. "Den nya amerikanska konsten," in: *Amerikansk Pop-konst* [exhibition catalogue], Stockholm, Moderna Museet, 1964, pp. 17–23, ills. 76–83. Reprinted in: *American Pop Art* [exhibition catalogue], Amsterdam, Stedelijk Museum, 1964; and with the title "The New American Art," in: *Art International* (Lugano), vol. VIII, no. 2, Mar., 1964, pp. 50–55, ill.

Stevens, W. "Angel Surrounded by Paysans, Poem," *Art in America* (New York), vol. 53, Oct., 1965, p. 32.

Stiles, Knute. "Sculptures for São Paulo, San Francisco Museum of Art," *Artforum* (Los Angeles), vol. 3, no. 1, Sept., 1964, p. 44.

Studio International (London), Feb., 1969: "New York Commentary."

Thomas, R. "Graphics: Alecto Gallery, London," *Art and Artists* (London), vol. 4, Feb., 1970, p. 28, ill.

Tillim, Sidney. "The Underground Pre-Raphaelitism of Edward Kienholz," *Artforum* (Los Angeles), no. 8, Apr., 1966, pp. 38–40.

Time (New York), Dec. 13, 1968, p. 84: "Art: Exhibitions – Presence is Plaster."

Time (New York), May 16, 1969, pp. 88–93: "Art: Pervasive Excitement for the Eye and Mind."

Time (New York), May 23, 1969: "Art in New York: Seven Artists."

Time (New York), Aug. 16, 1969, p. 44: "Art: Graphics."

Time (New York), Oct. 24, 1969, pp. 77–81: "Art: From the Brink Something Grand."

Tuchman, Phyllis. "American Art in Germany: The History of a Phenomenon," *Artforum* (Los Angeles), vol. 9, Nov., 1970, pp. 66, 67.

Wassermann, E. "This Year's Showing at the Sidney Janis Gallery," *Artforum* (Los Angeles), vol. 7, Feb., 1969, p. 68, ill.

Willard, C. "Drawing Today," *Art in America* (New York), vol. 52, Oct., 1964, p. 53, ill.

Exhibitions

One-Man Shows

1956 Hansa Gallery, New York.
1957 Hansa Gallery, New York.
1958 Hansa Gallery, New York.
Rutgers University, North Brunswick, New Jersey.
1960 Green Gallery, New York.
1962 Green Gallery, New York.
1963 Galerie Sonnabend, Paris.
Galerie Schmela, Düsseldorf.
Douglas College, North Brunswick, New Jersey.
1964 Green Gallery, New York.
1965 Sidney Janis Gallery, New York.
1967 Sidney Janis Gallery, New York.
1968 Museum of Contemporary Art, Chicago.
1968/69 Sidney Janis Gallery, New York.
1969 Princeton University, New Jersey.
Galerie Darthea Speyer, Paris.
1970 Western Gallery, Western Washington State College, Bellingham.
Sidney Janis Gallery, New York.
1971 Sidney Janis Gallery, New York.
Galerie Onnasch, Cologne.
Galerie Darthea Speyer, Paris.
1971/72 Kunsthaus, Zurich; Hessisches Landesmuseum, Darmstadt; Museum Boymans–van Beuningen, Rotterdam; Städtisches Museum, Leverkusen.

Group Shows

1956 Boston, Massachusetts: Boston Arts Festival.
1957 Jewish Museum, New York: Artists of the New York School: Second Generation.
1958 Sarah Lawrence College, New York.
1959 Carillon Museum, Richmond, Virginia.
1960 Whitney Museum of American Art, New York: Annual Exhibition of Contemporary American Drawings and Sculpture.
Newark Museum, New Jersey: New Jersey State Artists.
1961 Tour exhibition organized by the American Federation of Arts, New York: The Figure in Contemporary American Painting.
1962 Arts Council of the YM/YWHA, Philadelphia: Art 1963 – A New Vocabulary.
Art Institute of Chicago: 65th Annual American Exhibition.
Sidney Janis Gallery, New York: The New Realists.
1963 VII Bienal de São Paolo, US Section, organized by the Walker Art Center, Minneapolis, Minnesota: Ten American Sculptors.
1964 The Hague; Ghent; Stedelijk Museum, Amsterdam; Moderna Museet, Stockholm: American Pop Art.
Jewish Museum, New York: Recent American Sculpture.
Rose Art Museum, Brandeis University, Waltham, Massachusetts: Recent American Drawings.
Sidney Janis Gallery, New York: Three Generations.
1964/65 Carnegie Institute, Museum of Art, Pittsburgh: The 1964 Pittsburgh International. Exhibition of Contemporary Paintings and Sculpture.
1965 Whitney Museum of American Art, New York: A Decade of American Drawings, 1955–1965.
Milwaukee Art Center, Milwaukee: Pop Art and the American Tradition.
Sidney Janis Gallery, New York: Recent Work by Arman, Dine, Fahlstrom, Marisol, Oldenburg, Segal.
Worcester Art Museum, Worcester, Massachusetts: New American Realism, 1965.
The Solomon R. Guggenheim Museum, New York: 11 from the Reuben Gallery.
Musée Rodin, Paris: Modern Sculpture USA.
Palais des Beaux-Arts, Brussels: Pop Art, Nouveau Réalisme, etc.
Providence Art Club, Rhode Island: Kane Memorial Exhibition.
1965/66 Hochschule für bildende Künste, Berlin; Staatliche Kunsthalle, Baden-Baden (organized by the Kunstverein Berlin): Amerikanische Plastik. USA 20. Jahrhundert.
1966 Musée des Augustins, Toulouse: USA, art vivant.
Rhode Island School of Design, Providence: Recent Still Life – Painting and Sculpture.
Loeb Art Center, New York University, New York.
Walker Art Center, Minneapolis, Minn.: Eight Sculptors: The Ambiguous Image.
1966/67 Whitney Museum of American Art, New York: 1966 Annual Exhibition: Sculpture and Prints.
1967 The Museum of Modern Art, New York: Art of the Sixties.
The Solomon R. Guggenheim Museum, New York: Sculpture from 20 Nations.
Art Gallery of Ontario, Toronto; Albright-Knox Art Gallery, Buffalo: Dine, Segal, Oldenburg: Painting, Sculpture.
Los Angeles County Museum of Art; Philadelphia Museum of Art: American Sculpture of the Sixties.
University of St. Thomas Art Department, Houston, Texas: Mixed Masters.
Sidney Janis Gallery, New York: Exhibition of Work by Leading Artists in Homage to Marilyn Monroe.
City Art Museum of St. Louis: 7 for 67.
1967/68 Carnegie Institute, Museum of Art, Pittsburgh: Pittsburgh International Exhibition of Contemporary Painting and Sculpture.
IX Bienal de São Paolo, organized by the Smithsonian Institution, Washington; Museu de Arte Moderna, São Paolo: United States of America.
1968 Kassel: 4. Documenta.
Galerieverein, Munich; Kunstverein, Hamburg: Sammlung 1968 Karl Ströher.
Städtisches Suermondt-Museum, Aachen: Zeitbild-Provokation-Kunst.

94

Galerie Rudolf Zwirner, Cologne) Ac-
crochage: Bilder, Zeichnungen, Skulp-
turen.
Finch College Museum, New York: Jac-
ques Kaplan's Private Collection.
City Art Museum of St. Louis: Collectors'
Choice.
Tour exhibition organized by the Ameri-
can Federation of Arts, New York: Con-
temporary Drawings: Op, Pop and Other
Recent Trends.
San Antonio Fair, Texas: Sculpture,
Murals, and Fountains at Hemisfair '68.
New Jersey State Museum, Trenton: Art
from New Jersey.
Stedelijk van Abbemuseum, Eindhoven;
St. Pietersabdij, Ghent: Three Blind
Mice.
Newark Museum, Newark, New Jersey:
Three Environmental Happenings.
Seattle Art Museum Pavilion, Seattle
Center, Washington: The Virginia and
Bagley Wright Collection: Artists of the
Sixties.
Jewish Museum, New York: Superlimit-
ed: Books, Boxes, and Things.
Wallraf-Richartz-Museum, Cologne:
Sammlung Hahn.
Kunsthalle Darmstadt: Menschenbilder.

1969 Sidney Janis Gallery, New York: Seven
Artists: Dine, Fahlstrom, Kelly, Marisol,
Oldenburg, Segal, Wesselman.
Kölnischer Kunstverein, Cologne; Musée
d'Art et d'Histoire, Geneva; Palais des
Beaux-Arts, Brussels (organized by the
Smithsonian Institution, Washington):
Neue Figuration USA. Malerei, Plastik,
Film. 1963–1968.
Kunstverein, Berlin; Nationalgalerie der
Staatl. Museen, Berlin; Städtische Kunst-
halle, Düsseldorf; Kunsthalle, Bern:
Sammlung 1968 Karl Ströher.
Baltimore Museum.
Institute of Contemporary Arts, London:
The Obsessive Image.
University of Vermont, Burlington, Rob-
ert Hull Fleming Museum: Project 207:
Recent American Drawings.

Fort Worth Art Center Museum, Texas:
Contemporary American Drawing.
Krannert Art Museum, University of
Illinois, Champaign: Extension of the
Artist: Prints from the Collection of
Lydia and Harry Lewis Winston (Mrs.
Barnett Malbin).
The Museum of Modern Art, New York:
XXth Century Art from the Nelson A.
Rockefeller Collection.
The New School, New School Art Center,
New York: American Drawing of the
Sixties: A Selection.
Wallraf-Richartz-Museum, Cologne:
Kunst der sechziger Jahre: Sammlung
Ludwig.
The Grand Rapids Art Museum, Michi-
gan: American Sculpture of the Sixties.

1970 Metropolitan Museum of Art, New York:
New York Painting and Sculpture: 1940–
1970.
Sidney Janis Gallery, New York: Seven
Artists: New Work by Fahlstrom, Kelly,
Marisol, Oldenburg, Segal, Steinberg,
Wesselman.
Sidney Janis Gallery, New York: String
and Rope.
New Jersey State Museum, Trenton: Art
from New Jersey.
Boston University School of Fine and
Applied Arts, Centennial Exhibition:
American Artists of the Nineteen Sixties.
Expo Museum of Fine Arts, Daini Ban-
suiken Building, Tokyo: Expo '70.
Walker Art Center, Minneapolis, Minne-
sota: The Figure in Environment.
Neue Galerie, Aachen: Klischee – Anti-
klischee.
Indianapolis Museum of Art: Painting
and Sculpture Today.

1970/71 Carnegie Institute, Museum of Art,
Pittsburgh: 1970 Pittsburgh Interna-
tional. Exhibition of Contemporary Art.
Whitney Museum of American Art,
New York: 1970 Annual Exhibition. Con-
temporary American Sculpture.

1971 Society of Contemporary Art, Art Insti-
tute of Chicago: Contemporary Drawings.

Musée Rodin, Paris: IVe exposition inter-
nationale de sculpture contemporaine.
New Jersey State Museum, Trenton:
Anuszkiewicz – Segal.
Newark State College, Union, New Jer-
sey: Anuszkiewicz – Segal – Fangor.
Newark Museum, New Jersey: Third
Triennial of New Jersey Artists.
Museum of Contemporary Art, Chicago:
White on White.

1971/72 Palais des Beaux-Arts, Brussels; Mu-
seum Boymans–van Beuningen, Rotter-
dam; Nationalgalerie, Berlin; Palazzo
Reale, Milan; Kunsthalle, Basel; Musée
des Arts Décoratifs, Paris: Metamor-
phosis of the Object. Art and Anti-Art
1910–1970.

1972 Munson-Williams-Proctor Institute, Uti-
ca, New York: Recent Painting and
Sculpture.
Sidney Janis Gallery, New York: Abstract
Expressionism and Pop Art.
Emily Lowe Gallery, Hoftra University,
Long Island, New York: Green Gallery
Revisited.

Acknowledgment

The publisher's special thanks go to the Sidney
Janis Gallery, which with the valuable assist-
ance of Mr. Manuel Gonzalez has helped in
procuring the following illustrations: 15, 17
(top and bottom), 19, 20, 21 (top), 26, 28, 34,
35, 36, 38/39, 41, 42, 52, 53, 55, 56, 57, 58,
60, 62, 64, 65, 66, 70, 72, 74, 75, 76, 77, 78, 79

Photo Credits

Nancy Astor, New York: 35
Rudolf Burckhardt: 13, 33, 34, 36
Geoffrey Clements, New York: 15, 17 (top), 19,
42, 43, 48, 51, 54, 56, 57, 58, 77
Joseph Crilley, New Hope, Pa.: 73
Leco Photo Service, Inc., Flushing, N.Y.: 27
Peter Moore, New York: 60
Hans Namuth: Jacket, 45, 59, 63, 67, 80/81,
82–83, 86
O. E. Nelson, New York: 17 (bottom), 20, 84
Eric Pollitzer, Garden City Park, N.Y.: 21
(top), 30, 32, 41, 64, 66, 70, 72, 74, 75
Nathan Rabin, New York: 28, 53, 55
David van Riper: 25
Ed Roseberry: 21 (bottom)
Schmölz & Ullrich KG., Cologne: 29
Robert Schnur, Jamesburg, N.Y.: 26
George Segal: 6, 7 (top), 8, 12, 68, 85
Eric Sutherland: 61
Wallraf-Richartz-Museum, Cologne: 69
Herb Weitmann, St. Louis: 40
Anno Wilms, Berlin: 46